JORDAN

The Promise Fulfilled

JORDAN

The Promise Fulfilled

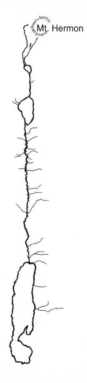

Mt. Hermon

Bonnie Gaunt

Adventures Unlimited Press
Kempton, Illinois 60946, U.S.A.

Adventures Unlimited Press
P.O. Box 74
Kempton, IL 60946 U.S.A.
auphq@frontiernet.net
www.adventuresunlimitedpress.com

Manufactured in the United States of America

ISBN 1-931882-59-2

Hebrew Gematria is based on the Masoretic Text
Greek Gematria is based on the Nestle Text

Cover art by Adventures with Nature, East Lansing, MI

Cover photo by Todd Bolen/BiblePlaces.com

Contents

Foreword

Forty years or more I have been studying and writing about the relationship of the Gematria of the Bible to the Sacred Geometry of the earth and our solar system. The magnificent harmony of the numbers has proven to be a priceless tool in providing abundant evidence for intelligent design in the creation of all things, and has given us a timeline for the past, present and future of man on this planet. Additional evidence of this pre-planned structure of all things had also been found in the harmony of the ancient monuments– Stonehenge and the Great Pyramid – whose inner and outer measures are in complete harmony with the Gematria of the Holy Scriptures. However, even with this evidence firmly established, I was unprepared for the magnitude and the magnificence of the evidence yet to be found in the Sacred Geography of the Great Rift Valley and the rivers which flow through it.

The Sacred Gematria, Sacred Geometry, and Sacred Geography of this awesome gash in the surface of our planet, provides a dynamic display of the whole story of the creation of man, his fall from original perfection, the promise of a redeemer, the coming and work of that Redeemer, and the future of man on planet earth.

While writing my previous book, *NILE: the Promise Written in Sand,* I became aware of the importance of the Jordan River in the completion of the story of the Great Rift

Valley. However, space did not permit its inclusion in that book. The story of the Jordan requires an entire book. The history and prophecy involved in this seemingly insignificant little river is enough to fill many books. I've merely scratched the surface of a subject that is awesome and magnificent.

The topography of this amazing little river, its elevation, its descent, its distances, combine with the Gematria of the Bible and the Sacred Geometry of the universe to reveal a plan that had been designed from the beginning of creation. Much of that plan is now authenticated history, which gives us confidence in its portrayal of things yet future.

My sincere thanks goes to Ronald M. Prosken for his help in the study, research, and understanding of the significance of this amazing river. And my heartfelt thanks and appreciation goes up to the awesome God whose blueprint and construction have given us this piece of magnificent Sacred Geography.

Bonnie Gaunt, 2006

Hebrew and Greek Gematria

		Gematria Value	Place Value			Gematria Value
Aleph	א	1	1	Alpha	α	1
Beth	ב	2	2	Beta	β	2
Gimel	ג	3	3	Gamma	γ	3
Daleth	ד	4	4	Delta	δ	4
He	ה	5	5	Epsilon	ε	5
Vav	ו	6	6	Zeta	ζ	7
Zayin	ז	7	7	Eta	η	8
Cheth	ח	8	8	Theta	θ	9
Teth	ט	9	9	Iota	ι	10
Yod	י	10	10	Kappa	κ	20
Kaph	ך כ	20	11	Lambda	λ	30
Lamed	ל	30	12	Mu	μ	40
Mem	ם מ	40	13	Nu	ν	50
Nun	ן נ	50	14	Xi	ξ	60
Camek	ס	60	15	Omicron	o	70
Ayin	ע	70	16	Pi	π	80
Pe	ף פ	80	17	Rho	ρ	100
Tsaddy	ץ צ	90	18	Sigma	$\sigma\ \varsigma$	200
Qoph	ק	100	19	Tau	τ	300
Resh	ר	200	20	Upsilon	υ	400
Shin	ש	300	21	Phi	ϕ	500
Tav	ת	400	22	Chi	χ	600
				Psi	ψ	700
				Omega	ω	800

There are 22 letters and 27 characters in the Hebrew Alphabet. The ancient Greek alphabet had 26 letters and 27 characters, but two letters have become obsolete.

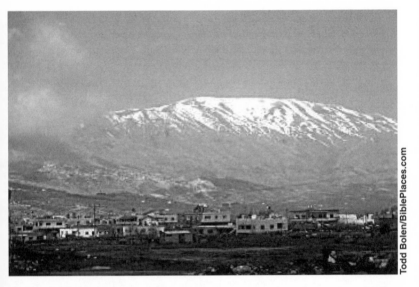

Mt. Hermon stands just north of the ancient border of Israel, providing its northern boundry. It is the greatest geographical resource of the area. Meltwater from its perennial snows seeps into its rocky pores, providing fresh pure water which finds its way into the Jordan River. This magnificent peak is truly the source of the Jordan.

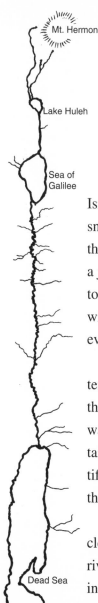

1

Jordan: the "Descender"

On a clear day, wherever you are in Israel, look up, and you will see beautiful snow-covered Mount Hermon dominating the northern horizon. It is always there, like a jewel in the sunlight – a beacon of hope to all who dwell in the land. From deepest winter to sweltering summer, its snows are ever seen, ever present, never failing.

As the warmth of the sun caresses the tender snow, it melts and gently seeps into the rocky mountain top, slowly finding its way deep into the foundations of the mountain, eventually bubbling up in three beautiful and refreshing fountains: the Hasbani, the Banias, and the Leddan.

These are the springs whose cold, clear, sparkling water becomes the Jordan river – the river whose history is intricately interwoven into the pages of the Bible.

From the northern-most fountain, the

Hasbani, the river descends 3,000 feet in a distance of 111 miles, before it silently disappears into the salt-laden waters of the Dead Sea, the lowest spot on the surface of our earth.

In the northern-most territory that had once been apportioned to the tribe of Dan, there flows another copious fountain, one of the largest springs in the world, the Leddan. The melting snows from Mt. Hermon feed this abundant fountain, whose waters issue forth in a stream about 20 feet wide. It is the central, and principle source of the Jordan, however Hebrew tradition attributes such an honor to the third spring – the Banias.

Two and a half miles east of the ancient city of Dan are the ruins of the city of Banias. It was called Caesarea Philippi in Jesus' day. From under its northern wall issues a lovely spring, claiming the honor of being the true source of the Jordan. Its clear, cold waters rapidly rush away to the southwest, in a plunging descent of white water. Lovely Banias Falls, in the Herman Nature Reserve is a special treat for tourists, inviting the traveler to come and rest awhile. Its sparkling water tumbles into the coolness of a shady glen – one of the most beautiful spots in Israel. From Banias to the Dead Sea, the river obtains a total length of 104.8 miles – but, of course, if we measured its many twists and turns, it would be much further. Its descent from Banias fountain to its entrance into the Dead Sea is said to be 2,376 to 2,380 feet.

The waters from the three fountains flow together into Lake Huleh, which is on the same level as the Mediterra-

nean Sea. Lake Huleh is said to be triangular. Because of its swampy areas it is difficult to define its shores. Some maps show it to be more the shape of an egg. In the Bible, this large lake was called *"the waters of Merom"* (Joshua 11:7). It is approximately 3.5 miles wide, and 4+ miles in length. Immediately as the water flows from the south end of Lake Huleh, it plunges down into the Great Rift Valley, which, at this place, is below sea level.

The entire length of the river, from Lake Huleh to the Dead Sea is below sea level – a span of 86.4 miles. In the course of this 86.4 miles, its tumbling muddy waters fall from sea level to about 1300 feet below the level of the Mediterranean, following the descent of the Great Rift Valley.

But this muddy plunge has a brief rest in the Sea of Galilee. The turbulent waters of the river come to rest in the sweet, cool, transparent waters of Galilee – a place of refreshment. This 12 mile segment of the river lies placid, shimmering in the tropical sun. Its waters abound with life, and for hundreds of generations men have found their livelihood in its abundance. It lies about 681 feet below sea level.

As the waters of the Jordan flow forth from the south end of the Sea of Galilee, they descend another 618 feet before reaching the Dead Sea. Measuring a straight line from the Sea of Galilee to the Dead Sea, tells us that this final segment of the river is 64.8 miles. The waters, of course, flow much farther because of the many turns in the river.

The Jordan is truly as its name implies. It is the "descender." Its course is directly south. A line of meridian can be drawn on its descent, which will pass through its northern-most fountain, the Hasbani, down through Lake Huleh, further down through the middle of the Sea of Galilee, tracing the path of the Jordan to its entrance into the Dead Sea.

But stand at the entrance of the Jordan into the Dead Sea and turn around. Look back from whence the river descended. On a clear day you will see the snow-capped peak of Mt. Hermon, forming the northern horizon of your view.

The true source of the Jordan is the white snow of Mt. Hermon.

2

Mt. Hermon: the Source

Mt. Hermon is at the lower part of the Anti-Lebanon Range, which runs about 93 miles in a northeast to southwest direction. The Hermon peak stands just north of the ancient border of Israel, providing its northern boundry.

The mountain forms one of the greatest geographical resources in the area. Because of its magnificent height (about 9,300 feet) it captures abundant precipitation in a country that is otherwise very dry. It literally provides life for the land below.

Meltwater from its snow-covered summit seeps into its rocky pores, providing a perennial flow of fresh pure water which becomes the Jordan river.

Throughout history, this beautiful, lofty mountain has been given many names. The Canaanites, who once occupied the land, called it Baal-Hermon, reflecting their

association of its snowy peak to their god Baal. The Sidonians called it Sirion. The Amorites called it Senir.

One of the loving appellations given to it was "the gray-haired mountain." A fitting observation of its snowy head. It was often called "the mountain of snow," and sometimes called "Sion" which, in Hebrew, means "peak."

Reference to all of these names can be found in the Bible, and, as with so many place-names and locations in the scriptures, as we read we tend to pass over them without comprehending their position or their importance to the story.

Mt. Hermon, however, stands in a very important geographical location in its relation to the land of Israel, and in relation to the entire plan of God for the salvation of man. The mountain represents the dwelling place of God, and the scriptures so present it. The cool, refreshing waters which bubble up from the springs at the foot of the mountain form a waterway rich in Biblical history, and rich in symbolism of the way of salvation through Jesus Christ.

God, speaking to Jeremiah, gave us a beautiful word picture of the life-giving pure water that flows from this lofty mountain. He said:

> *"Does the snow of Lebanon ever vanish from its rocky slopes? Do its cool waters from distant sources ever cease to flow?"* (Jeremiah 18:14 NIV)

This metaphor is far more than just poetic language. Looking deeper into its meaning opens an abundant store-

house of understanding. The *"snow of Lebanon"* is, of course, the snow covered peak of this lofty mountain in the Anti-Lebanon range – the mountain that provides the water of life.

Look again at that word *"snow."* It is the Hebrew word שלג, *sheleg*, from a Hebrew root meaning *to be snow-white.* If we assign the letters in this word their numerical equivalents, and add them, the sum will be 333.

Snow

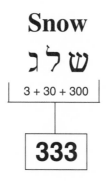

שלג

| 3 + 30 + 300 |

333

Thy throne O God is forever

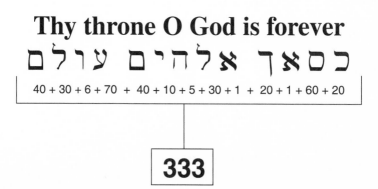

כסאך אלהים עולם

| 40 + 30 + 6 + 70 + 40 + 10 + 5 + 30 + 1 + 20 + 1 + 60 + 20 |

333

The number association is striking! They are both describing the same thing. The snow-covered peak of Mt. Hermon represents the throne, or dwelling-place of God. And there is more.

Analogies have been drawn showing the topstone of the Great Pyramid to represent the same thing as Mt. Hermon. This association of the two trangular peaks into the same pictorial metaphor is confirmed by the number values of their references in scripture. The Apostle Peter made an allusion to this when he quoted Isaiah, saying, *"Behold, I lay in Sion a chief cornerstone."* (I Peter 2:6) This quotation has a number equivalent of 333. In the book of Isaiah, this passage is the word of God to the prophet, thus it is obvious that He had reference to Jesus Christ as the One who shares that high position of *"chief cornerstone."* And it is also obvious that Peter used a play on words, for the Greek way of spelling Zion is Sion – and Sion, in Hebrew, means "peak." The reference is clearly to Jesus Christ, who called himself the *"Son of Man,"* also having a number value of 333.

333 = Snow
333 = Thy throne, O God, is forever, (Psalm 45:6)
333 = Behold I lay in Sion a chief cornerstone,
 (I Peter 2:6)
333 = The Son of Man, (John 3:14)

How interesting it is to note that the snowy peak of Mt. Hermon stands at 33.3° North latitude. And, if we use the meridian through Paris, which at one time was considered the Prime Meridian, the longitude of Mt. Hermon would be 33.3° East. It all seems to be well beyond the product of chance, and into the realm of evidence of a Master in its planning.

The concept of Zion and Sion (Jerusalem and Mt. Hermon) is used many times in scripture, and it is sometimes difficult for the reader to understand which mountain is being referenced. Sometimes it is both, and that is the reason for the play on words. In the King James Version, we find the statement in Psalms 48:1-3:

> *"Great is the Lord, and greatly to be praised in the city of our God, in the mountain of his holiness. Beautiful for situation, the joy of the whole earth, is mount Zion on the sides of the north, the city of the great King. God is known in her palaces for a refuge."*

However, if we read this same passage from the New International Version we see more clearly the interchange between Zion and Sion:

> *"Great is the Lord, and most worthy of praise, in the city of our God, his holy mountain. It is beautiful in its loftiness, the joy of the whole earth, like the utmost heights of Zaphon is Mount Zion, the city of the Great King. God is in her citadels; he has shown himself to be her fortress."*

The translators of the NIV chose not to translate the Hebrew word used here for "north," but instead called it Zaphon, which is a transliteration of צָפוֹן (sometimes צָפוֹן), the Hebrew for "north."

Clearly the Psalmist was making reference to Mt. Hermon, calling it *"his holy mountain,"* and *"the utmost heights of the north."* But poetically, he was using a play on words, interchangeably referring to Mt. Hermon (Sion) and Jerusalem (Zion), calling them *"the city of our God,"* and *"His holy mountain."*

Again, David used this same play on words and the same association of the two geographical locations. In Psalm 133:3 he said:

> *"It is as if the dew of Hermon were falling on Mount Zion. For there the Lord bestows his blessing, even life forevermore."* (NIV)

Literally there are 111 miles between the peak of Mt. Hermon and Mount Zion at Jerusalem, (when drawing a straight line between them), making it most unlikely that the literal dew from Mt. Hermon could fall on literal Mt. Zion at Jerusalem. Multiply 111 miles by the number of feet per mile, and divide by 660 and the distance between these two mountains becomes 888 furlongs. It bears the number of the name Jesus.

Distances, latitudes and longitudes throughout this book have been obtained from www.wcrl.ars.usda.gov/cec/java/lat-long.htm, and from the Student Map Manual: Historical Geography of the Bible Lands, Jerusalem, and from National Geographic maps.

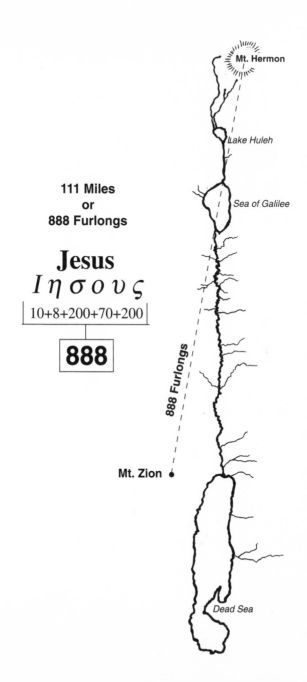

111 Miles
or
888 Furlongs

Jesus
Ι η σ ο υ ς

10+8+200+70+200

888

Mt. Hermon

Lake Huleh

Sea of Galilee

888 Furlongs

Mt. Zion

Dead Sea

What does Jesus have to do with Mt. Hermon and Mt. Zion? May I suggest that the *"dew of Hermon"* perhaps represents Jesus. He is the Agent of the Father through whom the blessing comes to Mt. Zion – the symbol of the seat of Divine Government which will engulf the world during earth's great Millennium. The prophet Micah, speaking of the time when Divine Government will fill the world, said:

> *"For the law shall go forth of Zion, and the word of the Lord from Jerusalem."*

These beautiful words, penned by the prophet Micah, have a Gematria value of 864. It is the solar number – the diameter of the sun being 864,000 miles. In the New Testament, the name Jerusalem has a number value of 864.

The interchangeableness of Mt. Zion and Mt. Sion tells us that both represent the seat of Divine Government, issuing forth from God, and administered by Jesus Christ.

The Psalmist again mixes the two locations into one metaphor which appears to include the sun:

> *"From Zion, perfect in beauty, God shines forth."* (Psalm 50:2)

Apparently this has reference to the snow covered peak of Mt. Hermon (Sion), which dazzled in the sunlight, and could be seen from Mt. Zion in Jerusalem.

Both of these Psalms (133:3 and 48:2) give us some interesting Gematria, again showing the conceptual connection between Mt. Hermon and Mt. Zion. In Psalm 133:3, if

we multiply the number equivalents of *"Dew of Hermon"* we obtain 5184. And if we add the number equivalents of *"Beautiful for situation, the joy of the whole earth is Mount Zion"* from Psalm 48:2, we again find the result is 5184. And in Psalm 133:3 *"It is as if the dew of Hermon were falling on Mount Zion"* has a Gematria value of 1548 (an anagram of 5184). These numerical connections are not just random numbers – they were encoded into the text, obviously not by the hand of man.

5184 = Dew of Hermon, (Psalm 133:3)
5184 = Beautiful for situation, the joy of the whole earth is Mount Zion, (Psalm 48:2)
1548 = It is as if the dew of Hermon were falling on Mount Zion, (Psalm 133:3)

The prophet Isaiah, speaking to one whom he called Lucifer, said:

> *"You said in your heart 'I will ascend to heaven; I will raise my throne above the stars of God; I will sit enthroned on the mount of assembly, on the utmost heights of the sacred mountain. I will ascend above the tops of the clouds, I will make myself like the Most High.'"* (Isaiah 14:13 NIV)

Whereas the NIV translates this *"heights of the sacred mountain,"* the KJV renders it *"in the sides of the north."* The Masoretic text reads, *"the utmost heights of Zaphon."*

All are clearly a reference to Mt. Hermon, situated on Israel's northern horizon. Using the Masoretic text, which of course is written in Hebrew, and multiplying the number equivalents for this phrase, *"utmost heights of Zaphon"* has a Gematria value of 3456.

In the Bible's number code, the number 3456 is magnificent. Revelation 3:12 speaks of *"the City of my God,"* which has a Gematria value of 3456 by addition. Another metaphor used to describe the dwelling place of God is *"The mountain of the height of Israel,"* in Ezekiel 20:40. It bears the number 3456 by multiplication. God's rulership over all His creation is simply stated as *"His dominion"* in Psalm 103:22, which has a Gematria value of 3456 by multiplication. He is the very personification of Truth *($\alpha\lambda\eta\theta\eta\varsigma$),* which also bears the number 3456 by multiplication. All of these references to the dwelling place of God share the same number, which is related to the sun. Draw a box around the sun, and the perimeter of the box will be 3,456,000 miles.

Sun

864,000 miles,diameter of sun

3,456,000 miles, perimeter of box

3456 = Utmost heights of Zaphon, (Isaiah 14:13)

3456 = The City of my God, (Revelation 3:12

3456 = The mountain of the height of Israel,
 (Ezekiel 20:40

3456 = His throne in the heavens, (Psalm 103:19

3456 = His dominion, (Psalm 103:22)

3456 = Truth

From all the above evidence, I believe we are correct in saying that Mt. Hermon represents God's dwelling place, and was understood as such in ancient Israel. Psalm 121:1 begins by saying:

> "I will lift up mine eyes unto the hills (הר, mountain), from whence cometh my help."

David knew the real source of his help was God, so he continued:

> "My help cometh from the Lord..."

But he looked north, to Mt. Hermon, as a representation of the source of his help.

In more modern times, organizations such as the Knights Templar and the Masons have taken the symbolism of Mt. Hermon as an integral part of their order, because of its location and its appearance. Their Supreme Councils of the 33rd Degree is, in fact, a reference to the location of Mt. Hermon, which is at 33° N, and 33° E (prior to 1884, when the prime meridian went through Paris).

The relationship of the snow covered peak of Mt. Hermon with the topstone of the Great Pyramid, and with the Father, the Son and the sun, becomes apparent from their uses in Gematria. The Hebrew word for sun is חמה, having a number value of 53. However, the Son, in the Greek text of the New Testament is υιον, bearing the same number value. And the peak of Mt. Hermon which reflects the sun relates to the Hebrew phrase *"Jehovah shall illuminate,"* (II Samuel 22:29), also bearing the number 53. The topstone of the Great Pyramid is sometimes called the *"headstone"* (אבן), whose number value is 53. Another name for the topstone is the *"cornerstone"* (פנת), also bearing the number 530. These are all related numerically and conceptually.

The span of the mountain range of which Mt. Herman is the peak, spreads for about 93 miles from northeast to southwest. Its peak (Sion) is about 9,300 feet above the level of the Mediterranean. It cannot be overlooked that the word *"love"* (αγαπη) has a number value of 93. This brilliant shining mountain peak is beautifully described by the following terms:

93 = Love
930 = Brightness (of the sun), (Acts 26:13)
930 = God is spirit, (John 4:24)
93 = To save life (Genesis 45:5)

Yes, it was God, who through His great love, sent His son Jesus Christ to purchase man from the sentence of death,

and give him the opportunity for everlasting life.

> *"For God so loved the world that he gave his only begotten Son, that whosoever believeth in him should not perish, but have everlasting life."* (John 3:16 KJV)

It is beautifully illustrated by the *"brightness"* from the sun coming 93 million miles to flood our earth with light, warmth and life. He was sent *"to save life"* (93).

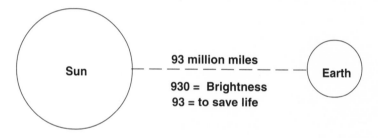

Convert 93 million miles to inches and divide by the speed of light, and the result will be 3168. It is the number equivalent for the name Lord Jesus Christ in the Greek text of the New Testament. It suggests the concept of the earth, as it spins on its axis, being flooded with sunlight every 24 hours – sunlight representing God's love being sent via the Lord Jesus Christ on behalf of man.

Jesus was a perfect man of 33 years old when he paid the price for the sin of Adam, and thereby purchased life for Adam and all of his posterity, the entire human race. At the age of 33 He represented the Father's love, being sent to earth on behalf of man – just as sunlight completely floods

our earth every 24 hours, bringing life to the earth. Multiply 33 x 24 and the result is 792, which is the Gematria value for the Hebrew word *"salvation."* Yes, the Lord Jesus Christ, whose number is 3168 in the Greek text, and 792 in Hebrew, came to earth, whose diameter is 7920 miles, to bring salvation (792).

God's ways are magnificent! And the shining peak of Mt. Hermon, positioned on Israel's northern horizon, representing God's love to man through Jesus Christ, was a constant reminder to King David of God's protection and love.

> *"I will lift up mine eyes unto the mountain, from whence cometh my help. My help cometh from the Lord."*

There is another magnificent relationship between Mt. Hermon and Mt. Zion that I find exciting. It is the use of the two creation numbers – 3 and 7. I call them "creation numbers" because these two numbers are fundamental to creation. In my 2003 book, *Genesis One*, is an in-depth study of these two creation numbers, all of which would be too lengthy to include here, but a few of the highlights are necessary to show the beauty of this awesome relationship of Mt. Sion to Mt. Zion.

It is well known that the first verse of the Bible is a magnificent display of the numbers 3 and 7.

37 x 73 = In the beginning God created the heaven and the earth.

John 1:1 tells us that this work of creation was done by the *"Word"* – which is an English translation of the Greek word *"Logos."*

373 = Logos, λογος

In Proverbs 8 we found a description of the relationship of the Logos to creation, but He takes a different name. He is the personification of Wisdom. And in Proverbs 3:19 we find the statement, *"The Lord by wisdom hath founded the earth."* The word *"wisdom"* in the Hebrew text is חכמה, which has a Gematria value of 73 and a place value of 37.

These basic numbers – 3 and 7 – define creation. Three is the first number to create shape, and 7 is the number representing perfection. All things were created in perfection, including man. And this is what we have so beautifully illustrated in snow-covered Mt. Hermon, situated at 33.3° N and 33.3° E – a representation of God in the creation of man through the Logos.

But Proverbs 8, after describing the works of creation, says, *"My delights were with the sons of men."* The Logos knew, even before He made man, that He would be their Redeemer, and this expression of His love is a beautiful foregleam of what He would actually accomplish for the human family – redemption and restoration to fulness of life. *"Wash me, and I shall be whiter than snow."* (Psalm

51:7) It is His redeeming blood that washes us whiter than snow. The numbers are magnificent.

33.3° N. latitude
33.3° E. longitude
333 = Snow, שלג
373 = Than snow, משלג
373 = Logos, λογος
 73 = Wisdom, חכמה
 37 = Wisdom (place value)
37 x 73 = In the beginning God created the heaven and the earth.

But, you ask, what does all this have to do with Mt. Zion?

The prophet Joel gave us the connection. He recorded the words God had spoken to him:

> *"Then you will know that I, the Lord your God, dwell in Zion, my holy hill (mountain)."* (Joel 3:17)

777 = in Zion, my holy hill, בציון הר קדשי

Mt. Sion is situated at 33.3° and Mt. Zion is represented by 777 – the two basic numbers of creation, 3 and 7. But they are given to us as triplets, and two triplets which are interwoven by the numbers 3 and 7.

$$3 + 3 + 3 = 9 \qquad 9 \times 37 = 333$$

$$7 + 7 + 7 = 21 \qquad 21 \times 37 = 777$$

Mt. Sion (333) is connected to Mt. Zion (777) by a distance of 888 furlongs.

$$888 = \text{Jesus, } \iota\eta\sigma\sigma\upsilon\varsigma$$

Jesus not only gave life to man in the beginning, which is represented by the pure water of life that is the dazzling white snow of Mt. Sion, He also restores life to man by means of His great sacrifice – the shedding of His blood – and brings to man the opportunity of restoration to all that had been lost by the sin of Adam.

"As in Adam all die, so also in Christ shall all be made alive." (I Corinthians 15:22)

This restoration work is symbolized by Mt. Zion, which represents Divine Government – a kingdom of righteousness. The prophet Micah stated it succinctly when he wrote:

"The Law shall go forth from Zion, and the word of the Lord from Jerusalem." (Micah 4:2)

The pure, cold water from the melting snows on Mt. Hermon's lofty peak, seep down into the rocky interior of the mountain, and emerge below as fresh copious fountains of water, whose flow never ceases, even in the hottest of a dry summer. God's love through Jesus Christ never ceases, and the offer of life which it represents, never dries up.

In the beginning, the freshness of life without end was given to Adam. It was like the sweet cool water flowing from the snows of Mt. Hermon. He was placed into a beautiful garden and given an abundance of all that he needed, including personal communion with God.

Refreshing Fountains

In the beginning, the freshness of life without end was given to Adam. It was like the sweet cool water flowing from the snows of Mt. Hermon. He was placed into a beautiful garden and given an abundance of all that he needed, including personal communion with God.

The snows of Mt. Hermon, melting in the warmth of the sun, trickle down into the interior of the mountain, through its rocky channels, and emerge at its foot as lovely fresh flowing fountains of cool water.

There are three principal fountains from which the snows of Mt. Hermon emerge as perennial springs of fresh water. The largest of these is the Leddan: one of the largest springs in the world. It takes its name from the tribe of Dan, for it was in the territory of northern Israel

which had been given to the Danites by Joshua after the conquering of the land.

The sparkling waters of the Dan river converge with the Hermon river a few miles south of the spring. The Hermon river flows from a beautiful fountain at the ancient town of Caesarea Philippi. The spring is called Banias. Undoubtedly Jesus stood beside this fountain when he visited Caesarea Philippi with his disciples. It was here that he talked to them about his coming Kingdom.

The fountain at Banias has always been regarded as the true source of the Jordan, although it is only one of three such fountains. The waters issue forth from a grotto at the base of a lofty limestone cliff, and makes a hasty descent, pouring forth over the lovely falls in the Hermon Nature Reserve, in its rush to meet the Dan a few miles downstream.

A third fountain rises from the bottom of a valley at the western base of Mt. Hermon. It is the Hasbani. Its waters rush down to meet the outflow from Leddan and Banias, and together they plunge rapidly toward Lake Huleh.

The Gematria for the three names – Leddan, Banias, and Hasbani – is magnificent. These three fountains pour forth the water from Mt. Hermon's peak – the *"Sion."* And together, the number equivalents of their names total 333. It is a magnificent demonstration of their relation to Mt. Hermon, which sits at 33.3° latitude and 33.3° longitude (by the old method).

In the previous chapter we saw the beauty of this rela-

tionship of the number 333 to Mt. Hermon. The Gematria identified its meaning as the place where God dwells.

333 = Snow

333 = Thy throne, O God, is forever, (Psalm 45:6)

333 = Behold I lay in Sion a chief cornerstone,
 (I Peter 2:6)

333 = The Son of Man, (John 3:14)

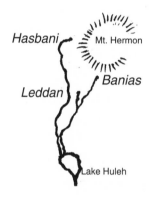

127 = Hasbani, הסבני
84 = Leddan, לדן
122 = Banias, בנים

333

 This relationship of these three names to Mt. Hermon, sitting at 33.3° by 33.3° is worthy of special notice. It is obviously not a random coincidence. It speaks loudly of divine design, suggesting that God is the fountain from which

all life flows. And it does not escape notice that the Gematria value for *"fountain of water,"* (מים מעין) is 260, and the value for God (Yahweh) is 26.

As we have seen, the source of the water – the snow of *"Sion"* is the brilliance of its reflection of the sun, bearing the number 53, which is the Gematria value of *"sun."* Just so, the fountains from which flow this pure life-giving water also bear the number 53.

530 = The Lord, the fountain of living water. (Jeremiah 17:13)

These fountains are also identified with the water from the snows of Hermon by other Hebrew words:

260 = Fountain of water, מים מעין
26 = God (Yahweh), יהוה

436 = Fountain of water, מקור מים, (Jeremiah 2:13)
436 = The majesty of Jehovah, גאות יהוה, (Isaiah 26:10)
436 = God of my salvation, אלהי ישע, (Psalm 25:5)

Perhaps the most beautiful of these number-allusions to the Creator is the number 18. Wherever it is found in the Gematria of the Bible, with reference to God, or to His agent in creation, the Lord Jesus Christ, it gives the obvious meanings of: 1 – the Beginning (or Beginner), and 8 – the New

Beginning, (New Beginner). Just so, it is not surprising to find it here in these three springs whose waters supply the never-ending flow from the snows of Mt. Hermon. The Hebrew word for *"springs"* is מעירי, bearing a Gematria value of 180.

Although these three perennial fountains supply most of the water for the Jordan river, yet there are said to be 70 more smaller springs in the Huleh Valley, feeding the rich marsh land and Lake Huleh.

The Huleh Valley is clearly defined by the highlands which surround it. This fertile valley covers an area of 73 square miles. The lake, filling the southern portion of the valley, covered approximately 9 square miles, prior to the drainage project (1951-1958) which reduced its size, and left dry much of its swampy surroundings.

Fresh clean water was in abundance. The average annual 60 inches of precipitation (mostly snow) falling on Mount Hermon supplied the 73 springs which water the fertile valley. Those 60 inches are obviously 5 times 12, suggesting Divine Law (12) multiplied by grace (5). Such was the condition into which man was created. He was placed into a fertile, well-watered garden, and given Divine Law, administered by grace. The 3 plus 70 springs supplying the water suggest the creation numbers – 3 and 7.

> *"And God said, Let us make man in our image, after our likeness.... So God created man in his own image, in the image of God created he him;*

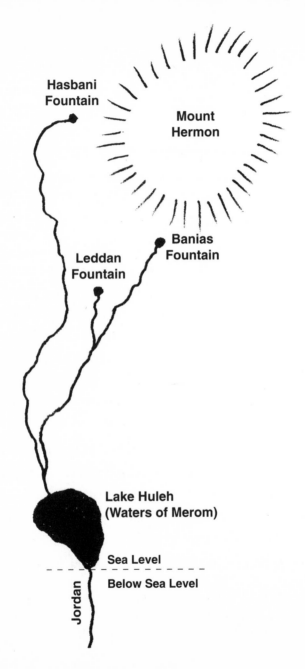

Hasbani
Fountain

Mount
Hermon

Banias
Fountain

Leddan
Fountain

Lake Huleh
(Waters of Merom)

Sea Level

Below Sea Level

Jordan

28 Jordan: the Promise Fulfilled

male and female created he them.... And God saw every thing that he had made, and, behold, it was very good." (Genesis 1:26-31)

"And the Lord God planted a garden eastward in Eden; and there he put the man whom he had formed. And out of the ground made the Lord God to grow every tree that is pleasant to the sight, and good for food ... and a river went out of Eden to water the garden; and from thence it was parted, and became into four heads." (Genesis 2:7-10)

I am *not* suggesting that the Garden of Eden was in the Huleh Valley. However, I *am* suggesting that the latter is a picture of the former – a beautiful picture, planted in the earth from the beginning. It illustrates man's condition of perfection, supplied with all his needs in abundance. It was the condition into which God placed the man He had created.

But Adam violated Divine Law, and as a consequence, he was driven out of the perfect Garden. At the south end of Lake Huleh the water plunges into the Great Rift Valley and begins its rapid downward course, eventually being swallowed up by the stagnant waters of the Dead Sea. A great rift between God and man happened when Adam disobeyed Divine Law, and fell from Divine Grace.

Lake Huleh is not mentioned by that name in the Bible. It is called *"the waters of Merom."* When looking this up in

a Hebrew Lexicon I was delighted to find this definition: "A lake situated in a *lofty* place at the foot of Mount Hermon." The Hebrew word Merom (מְרוֹם), in fact, means *lofty,* or a *high place.* A slightly different pronounciation, but with the same Hebrew letters, is מָרוֹם, translated *"Most High"* – using it as a name for God.

The *waters of Merom* was a fertile place, characterized by its tranquility and its richness as a habitat for birds and wildlife. It is a beautiful illustration of the perfect life given to Adam by his loving benevolent Maker. It was life that was intended to be forever. And God's intentions never fail. Those refreshing fountains will indeed flow with life for all of Adam's family, but first, they must come to full realization of the results of disobeying Divine Law. For six thousand long and tragic years Adam's family have come face to face with the awful results of Adam's disobedience. But God's plans for His human family will not be thwarted. They will indeed receive the refreshing water of life prepared for them from the beginning.

A substitute for Adam has been found – it is Jesus Christ. In the scriptures he is called the *"Last Adam."* He shed his innocent blood in place of the guilty blood of the first Adam. He paid the price, thus, salvation for us is free.

Just as Lake Huleh is somewhat egg-shaped, so is the Sea of Galilee. Both bodies of water are nearly identical in shape. Galilee is a beautiful illustration of life through Jesus Christ.

Sea of Galilee

The river flows about nine torturous miles from Lake Huleh to the Sea of Galilee. In these nine turbulent miles, its foaming torrent plunges through a steep narrow gorge on the western side of the Golan Heights, dropping 681 feet before entering the Sea of Galilee.

This beautiful sea occupies an expansion of the Jordan Valley. It's as if it *"stands in the gap"* between the upper Jordan and its continuing descent into the Dead Sea. It is fully within the boundaries of the Great Rift, but is a placid sea of blue, where the muddy waters from above find rest. The silt-laden waters entering it become settled, and the lake takes on a transparent appearance, reflecting the deep blue of the sky.

Life is abundant in this refreshing sea. Its fishing industry has thrived for thousands of years. It was from this fertile sea that

Jesus chose fishermen to be his special companions. It was this sea whose turbulent surface He walked on during a storm. It was this sea whose waters He calmed by His command, *"Peace! Be still!"* And on the grassy banks beside this sea He fed the five thousand and the four thousand (9,000 in all. A number which represents fullness and completion).

Yes, this sea stands in the breach (the Great Rift), calming its waters and bringing life in abundance. How beautifully it pictures the One who *"stands in the breach"* for fallen mankind.

In Psalm 106:23 we are given an illustration of one who stood in the breach. It tells of Moses *"His chosen stood before him in the breach,"* who is an illustration of Jesus, standing in the breach for fallen man, *"to turn away his wrath,"* – the wrath of God against sin.

It is not by accident, nor by blind coincidence that the phrase *"His chosen stood before him in the breach"* has a Gematria value of 888. For Jesus, the One standing in the breach for mankind, also bears the number 888.

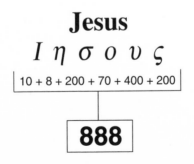

Jesus

$I \ \eta \ \sigma \ o \ \upsilon \ \varsigma$

| 10 + 8 + 200 + 70 + 400 + 200 |

888

The concept of Jesus, standing in the breach for mankind, was emphasized by the Apostle Paul when he said:

"For there is one God, and one mediator between God and men, the man Christ Jesus; who gave himself a ransom for all." (I Timothy 2:5-6)

As a confirmation for identifying this *"mediator between God and men"* with the man Christ Jesus, God has given us his identification number, for its Gematria value is 3168 – the same value as the name Lord Jesus Christ.

```
3168 = Mediator between
       God and men
3168 = Lord Jesus Christ
```

The prophet Isaiah identified him as the One standing in the breach for all the family of Adam, bearing the price of sin. He said:

"He shall see the travail of his soul, and shall be satisfied: by his knowledge shall my righteous servant justify many; for he shall bear their iniquities." (Isaiah 53:11)

Perhaps Isaiah did not realize that, by this statement, he was giving us the identification number of the One of whom he was prophesying.

```
3168 = He shall see the travail of his
       soul, and shall be satisfied; by
       his knowledge shall my
       righteous servant  justify many;
       for he shall bear their iniquities.
3168 = Lord Jesus Christ
```

Yes, the Sea of Galilee, standing in the breach – the Great Rift between God and men – beautifully represents Jesus Christ, who came to stand in that breach as the mediator. He accomplished this by being the *"Last Adam,"* giving his life in place of the first Adam. Perhaps this is why he was called The Galilean.

In the Hebrew text of the Old Testament the Sea of Galilee is mentioned using a word which means *"circle"* and another word meaning *"circuit."* The first, גליל, *Galiyl,* meaning *"circle,"* has a Gematria value of 73, (7 and 3 being the numbers of creation). But it is also the value of the Hebrew word החיים, *ha-chiam, "life."* As the Logos (373) he created man, and gave him life (73); but as the man Christ Jesus he restored that life (73). You might say he brought man "full circle" or *"Galilee"* (73).

The second word used in the Old Testament for this beautiful sea is גלילה, *Galiylah,* meaning *"circuit."* It has a Gematria value of 78. Again Isaiah identified him as the

"Man of Sorrows," which has a Gematria value of 780.

Perhaps these references to *circle* and *circuit* are suggesting that we look at the circuit of the sea of Galilee – the circuit of its shoreline – for another possible clue to its identification.

This magnificent sea is not in the shape of a circle. It more resembles that of an egg. Some writers suggest it is "pear shaped." However, if we measure the circuit of its shoreline we find that, amazingly, it is 33 miles. What a remarkable number!

Jesus came to earth for the purpose of paying the price, or making atonement, for the sin of Adam. He became the atonement offering – the price of sin. How amazing to find that the Hebrew word meaning *"to atone"* has a Gematria value of 330. He was 33 years of age when this transaction was completed. The Gematria is amazing.

330 = The holy and just One
330 = Atonement
330 = Pain

You might say that *"the holy and just One,"* (330) Jesus, at the age of 33, paid the price of *"atonement"* (330) at the cost of much *"pain"* (330).

And it does not go unnoticed that the Sea of Galilee is essentially the same shape as Lake Huleh. Why would they

be the same? Perhaps because the reason Jesus paid the price of atonement was to restore to man all that Adam had lost through his disobedience to Divine Law. And their shapes, resembling an egg, suggest the springing forth of life.

Whatever its shape – a pear, an egg, or a circle – this magnificent sea of tranquil water divides the distance between Mt. Sion and Mt. Zion at its Golden Proportion. It stands in the breach, filling the Great Rift from east to west, and calms the torrent of the Jordan.

"His chosen stood before him in the breach."

It has a Gematria value of 888. The straight line distance from Mt. Sion to Mt. Zion is 888 furlongs; and the Gematria value of the name "Jesus" is 888.

Why would the Sea of Galilee, representing Jesus Christ, stand in the gap (the Great Rift Valley) between Mt. Sion and Mt. Zion at the Golden Proportion? What is the Golden Proportion, and what has it to do with Jesus Christ?

The Golden Proportion is a physical constant. Physicists have called it "The Growth Constant" because its proportions "grow" in a mathematical pattern that repeats and multiplies. All "growth" in nature is based upon this constant. Plato called it the most binding of all mathematical relations, and the key to the physics of the cosmos. It is, in fact, the relationship of Unity to creation.

The first act of creation was the division of Unity, but a very special kind of division, in which 1 (Unity) can be

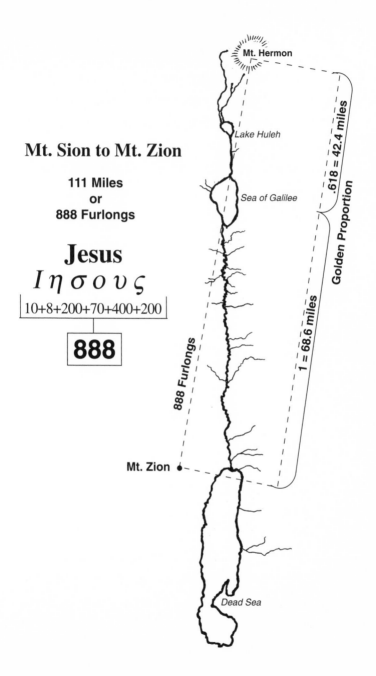

Mt. Sion to Mt. Zion

111 Miles
or
888 Furlongs

Jesus
$I\eta\sigma o\upsilon\varsigma$

| 10+8+200+70+400+200 |

888

Mt. Hermon

Lake Huleh

Sea of Galilee

.618 = 42.4 miles

Golden Proportion

1 = 68.6 miles

888 Furlongs

Mt. Zion

Dead Sea

expressed in two terms. In geometry, this occurs only when the smaller term is to the larger term as the larger term is to the smaller plus the larger. This may sound confusing, but it can be illustrated quite simply.

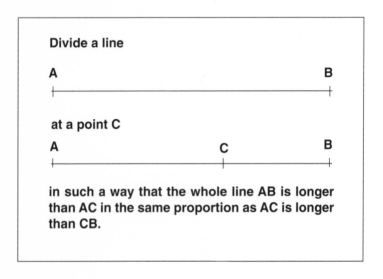

Divide a line

A B
├──┤

at a point C

A C B
├─────────────────────────────────┼──────────────┤

in such a way that the whole line AB is longer than AC in the same proportion as AC is longer than CB.

Thus when Unity is divided, that which is separated becomes part of the whole. The ratio is 1:1.618. In mathematics, the Greek letter ϕ (pronounced *phi*) is used as a symbol of this proportion. It describes the most intimate relationship that the created can have with the Creator – the primal divison of One. Mathematicians use either the full ratio, or its shortened version. Both are used in the Gematria of the holy scriptures. In this book I will be using primarily the shortened version, which is .618.

To show this primal relationship between Unity and the division of Unity (the Father and the Son), let's look at the very first act of creation, *"The breaking forth of light."* It's Hebrew word is כשחר bearing the Gematria value of 528. To do this we draw a square, then project its Golden Proportion (the rectangle to the left). Within this Golden Rectangle we inscribe a spiral connecting its corners. This is the spiral we see in all nature. We see it in the seed pattern of the sunflower, the swirl of hair on the crown of the human head, the spiral of the nautilus shell, and the spiral of the galaxy of which our Solar System is a part. This proportion abounds in our Universe. It is basic to all creation for it begins with the Lord Jesus Christ, the One through whom all creation came into being, and the *"breaking forth of light,"* the first act of his creation work.

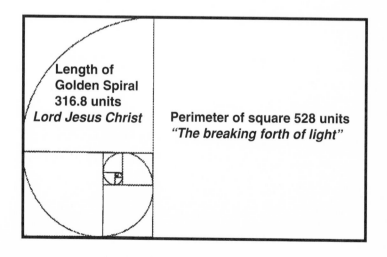

Length of Golden Spiral 316.8 units *Lord Jesus Christ*

Perimeter of square 528 units *"The breaking forth of light"*

The relationship of Jesus Christ to the Golden Proportion is fundamental to creation. Even the place where he was born forms a Golden Proportion in relation to the size of the earth. Bethlehem is positioned at 31.68°N latitude – not a random coincidence. And when we view that spot on earth in relation to the entire globe, we find again a Golden Proportion. Consider our earth as a perfect sphere by using its mean diameter, and we will find that the latitide of 31.68° will form a Golden Rectangle in relation to the entire earth.

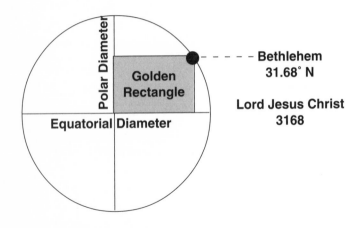

Even the prophecy of His birth in the Old Testament and the fulfillment of that prophecy in the New Testament bear the proportions of this Golden Ratio. The prophet Micah wrote:

"You, Bethlehem Ephratah, you who are little among the thousands of Judah, out of you shall He come forth to Me to be ruler in Israel, and

His goings forth have been from of old, from the days of eternity." (Micah 5:2)

This identification of the place of his birth bears the same number in both the prophecy and its fulfillment, even though written in different languages, and using different words. Compare them. They are beautiful!

1958 = You, Bethlehem Ephratah, you who are little

ואתה ביתלחם אפרתה צעיר

1958 = You, Bethlehem in Judea (Matthew 2:6)

συ εν Βηθλεεμ της Ιουδαιας

If we divide 1958 by the Golden Proportion we obtain 3168, the number of his name. Thus 1958 ÷ .618 = 3168.

The Golden Proportion is also shown in his death, which took place on a hill called Calvary, which means *"place of the skull."* But that hill had another name. It was Golgotha, which is derived from the Hebrew גלגל *(galgal)*, meaning a circle, or to roll. It is from the same Hebrew root as Galilee.

301 = Calvary, κρανιον
186 = Golgotha, γολγοθα

If we divide 186 by the Golden Proportion we obtain 301, thus 186 ÷ .618 = 301.

The association is magnificent! It is telling us that both

his birth and his death are connected to the concept of the Golden Proportion and the circle – Galilee.

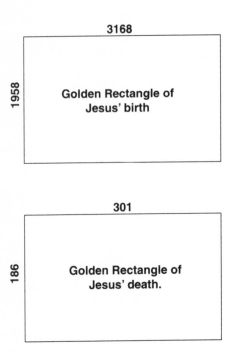

Many of the ancient prophecies identify Jesus with the Golden Proportion. One such prophecy was spoken by Jacob on the occasion just before his death when he called his twelve sons before him and pronounced a prophecy upon each. When he came to Judah, this is what he said:

"Judah is a lion's whelp; my son, you have gone up from the prey; he stoops, he crouches like a

lion; and like a lioness, who can rouse him up? The sceptre shall not depart from Judah, nor a lawmaker from between his feet, until Shiloh come, and the gathering of the people shall be to him. Binding his foal to the vine and his ass's colt to the choice vine, he washes his clothing in wine, and his raiment in the blood of grapes. His eyes shall be dark from wine, and his teeth white from milk." (Genesis 49:10)

The translation into English somewhat obscures the meaning in places. It makes more sense in Hebrew. It is a prophecy of the coming of Jesus as the *"Lion of the tribe of Judah"* and as Shiloh, the peacemaker. The portion dealing with the sceptre is replete with Golden Proportions.

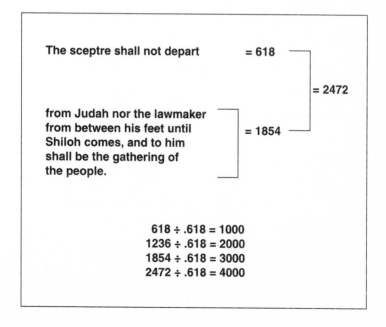

The sceptre shall not depart = 618 ⎤
 = 2472

from Judah nor the lawmaker from between his feet until Shiloh comes, and to him shall be the gathering of the people. = 1854 ⎦

618 ÷ .618 = 1000
1236 ÷ .618 = 2000
1854 ÷ .618 = 3000
2472 ÷ .618 = 4000

The prophecy is talking about rulership. And many centuries later, the prophet Zechariah was given a message from the Lord and wrote, *"The Lord shall be king over all the earth."* It has a Gematria value of 618, the numbers of the Golden Proportion.

The prophet Malachi also spoke of that coming day when Jesus would set up his kingdom – Divine Government – that will rule the entire world. He said: *"Who can endure the day of his coming? Who can stand at his appearing?"* The Hebrew word for *"his appearing"* is הראותו, which has a Gematria value of 618.

And that great prophecy of the Suffering Servant in Isaiah 53 foretold: *"By his wounds we are healed."* Isaiah probably did not know that he was giving us the Golden Proportion when he said *"By his wounds"* (בחברתו). It has a Gematria value of 618.

The prophet Zechariah spoke of the wounds that Jesus would receive in his hands – the wounds left by the nails with which they hung him on the cross. He said, *"What are these wounds in thine hands? Then he shall answer, Those with which I was wounded in the house of my friends."* (Zechariah 13:6) The prophet was probably unaware that he was giving a clue to the great importance of the Golden Proportion in the life and death of Jesus Christ. But the phrase *"these wounds in thine hands"* have a Gematria value of 618.

So, the prophet Isaiah revealed the fact that the One

Mt. Hermon

Lake Huleh

Sea of Galilee

The descent of the river from the Sea of Galilee to the Dead Sea is a drop in elevation of 618 feet.

Dead Sea

who was wounded would, in turn, heal the wound that had been inflicted upon mankind by the sin of Adam. He said, *"... in the day that the Lord bindeth up the breach of his people, and healeth the stroke of their wound."* (Isaiah 30:26) The phrase *"the breach of his people"* has a Gematria value of 618. Yes, the great breach between God and man, pictured by the Great Rift Valley is being repaired by Jesus Christ, who, in symbol, is the beautiful Sea of Galilee, filling the breach. He is the *"repairer of the breach"* (Isaiah 58:12).

618 = I will repair, גדרתי (Amos 9:11)

And so, when I read that the descent of the Jordan, from the Sea of Galilee to the Dead Sea is a drop in elevation of 618 feet, the tingles began going up the back of my neck. It was a clue that I should dig deeper, for there was much beauty to be discovered.

Looking at the map, it appeared that a Golden Proportion did indeed exist at the point where the water flows south out of the Sea of Galilee. So I measured. Between the Banias fountain and the Dead Sea, a straight line measure is 104.8 miles. Its Golden Proportion would look like this.

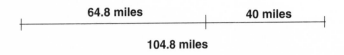

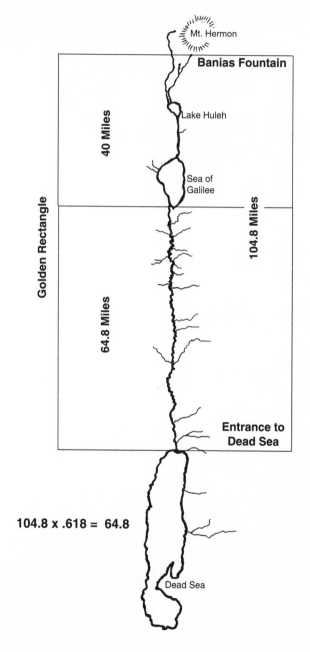

Mt. Hermon

Banias Fountain

Lake Huleh

Sea of
Galilee

40 Miles

Golden Rectangle

104.8 Miles

64.8 Miles

**Entrance to
Dead Sea**

104.8 x .618 = 64.8

Dead Sea

Sea of Galilee 47

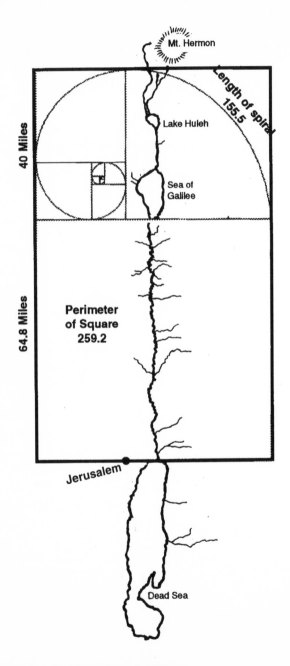

Mt. Hermon

Length of spiral 155.5

40 Miles

Lake Huleh

Sea of Galilee

Perimeter of Square 259.2

64.8 Miles

Jerusalem

Dead Sea

48 Jordan: the Promise Fulfilled

When I overlaid the Golden Rectangle on the map of the river, the relationship became obvious. A Golden Ratio is indeed involved in the design of the river. Was it intentional? What is its meaning?

The Sea of Galilee, *"standing in the gap"* between God and man, represents Jesus Christ. The distance from the Sea of Galilee to the Dead Sea is a straight line of 64.8 miles. The river still represents Adamic death, but now there is hope of deliverance from death. And this hope of deliverance is the surety for all who die in Adam. Its Gematria is magnificent.

648 = A fountain from the house of Jehovah
מעין מבית יהוה (**Joel 3:18**)

648 = God will provide a Lamb
אלהים יראה לו השה (**Genesis 22:8**)

648 = Make alive, $\theta\eta\sigma o\nu\tau\alpha\iota$ (I Corinthians 15:22)

Yes, Jesus is the life-giving *"fountain"* from the house of Jehovah. He is the "Lamb" slain from the foundation of the world. And it is he who will *"make alive"* all of Adam's family – the entire human race.

And when we overlay the Golden Rectangle on the Jordan River, the distance of 64.8 miles becomes one side of a rectangle whose perimeter is 259.2 miles. The number is immediately recognizable as the circuit of the sun through

the twelve constellations of the Zodiac, for it takes 25,920 years for the sun to make one circuit through the Zodiac. It is called the "Great Year."

Why is the sun involved in this calculation of the distance between Galilee and the Dead Sea? It is because the sun is the provider of all life on earth – it represents God. It does not go unnoticed that the distance of 64.8 miles is an anagram of the solar number, 864.

864,000 miles – Diameter of the sun

864 = God, *Θεων*

864 = Before me there was no God formed, neither shall there be after me. (Isaiah 43:10

לפני לא נוֹצר אל ואחרי לא יהיה

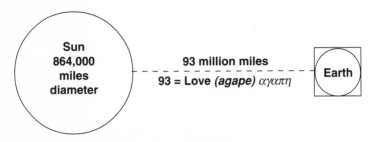

93 million miles converted to inches, divided by the speed of light = 3168

Diameter of earth 7,920 miles
Square around earth 31,680 miles

792 = Lord Jesus Christ (Hebrew)
3168 = Lord Jesus Christ (Greek)

This illustration of light from the sun bathing the earth in light and warmth every 24 hours is telling us in brilliant reality:

"God so loved the world that he sent his only begotten son, that whosoever believeth in him should not perish but have everlasting life." (John 3:16)

It is a global concept. *"As in Adam all die, so also in Christ shall all be made alive,"* (I Corinthians 15:22). No one is left out.

Look again at the illustration of the Golden Rectangle on page 48. The perimeter of the square drawn on the distance from the Sea of Galilee to the Dead Sea is 259.2 miles. It is a number that describes the entire circuit of the sun through the ecliptic.

Each year the sun makes its annual circuit through the twelve constellations of the Zodiac, but with each circuit, it slips back slightly, so that when it completes one year, it has not precisely completed one cycle. This is called the precession of the equinoxes. After a long term of 25,920 years, it returns to the starting point. This 25,920 years is called the Great Year of the celestial cycle.

These twelve constellations of the Zodiac are a beautiful portrayal of the entire plan of God for the salvation of man. They were put there, in their relation to the earth, by the Creator. Thus He has assured his human family, from the beginning, that He has it all in control, and that He has

planned for man's salvation, even before He created Adam.

The fact that the long period of the celestial cycle bears the same number as the Gematria for the twelve constellations, is a marvelous display of the pre-planning of God. It tells us that He is in control, and the outworking of His plan is progressing exactly as originally designed.

Here are the names of those twelve constellations, and their Hebrew Gematria[1].

Virgo	145 = virgin, עלמה
Libra	56 = balances, מאיה
Scorpio	372 = scorpion, עקרב
Sagittarious	171 = horse-man, אדם-סוס
Capricornus	580 = goat, שעיר
Aquarius	180 = "waters flow from his buckets" (Numbers 24:7) מים מדליו
Pisces	12 = fish (female fish), דגה
Aries	41 = ram, איל
Taurus	250 = reem, רים
Gemini	441 = twins, תאם
Cancer	261 = "to bind together," אסר
Leo	83 = lion, (roaring lion), לבאים

2592

1 For a complete description and significance of the 48 constellations, their Gematria, and their place in the plan of God, please see my 1999 book *The Coming of Jesus: the Real Message of the Bible Codes.* Available from Adventures Unlimited Press, 1-800-718-4514, or auphq@frontiernet.net.

The Golden Rectangle overlaid on the Jordan River, as shown on page 48, shows the entire distance from Banias fountain to the Dead Sea, with the division of the Golden Proportion at the south end of the Sea of Galilee. This upper portion – Golden Rectangle projected above the square – has a short side of 40 miles, and a long side of 64.8 miles. A spiral connecting the corners within this Golden Rectangle will have a length of 155.5 miles.

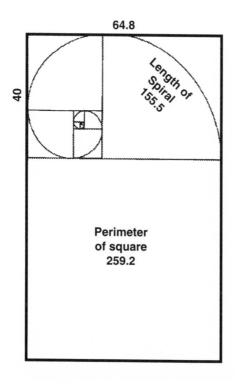

It is a number relating directly to Jesus Christ. At the beginning of Jesus' ministry, he was walking on the road

one day where John (the Baptist) and two of his disciples were standing. John said to his disciples, *"Behold, the Lamb of God.."* They began to follow him to find out more. And Jesus invited them to spend the night with him. Undoubtedly, during that visit, Jesus must have told them many things that we would love to know and understand. And he must have revealed to them that he was the One whom the prophets had foretold would be their deliverer.

One of those disciples was Andrew, and he wasted no time in running to find his brother, Simon Peter, to tell him the exciting news. I can imaging how his heart must have overflowed with jubilation as he found his brother and exclaimed to him *"We have found the Messiah!"*

This exciting item of history has been recorded for us in the Gospel of John, chapter 1 verse 41. The original Greek text reads *ευρηκαμεν τον Μεσσιαν,* and it has a Gematria value of 1555, the same number as the length of the spiral in the Golden Rectangle between Banias fountain and the south end of the Sea of Galilee. But this statement and its Gematria have a very special beauty in that its numbers form a palindrome because they are mirror opposites.

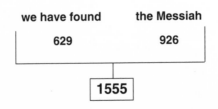

Yes, there were a few Israelites who recognized him as their long-promised Messiah. The majority, however, did not. But their day is coming, because it is prophesied that *"They shall look upon Him whom they pierced,"* (Zechariah 12:10). And this statement, also, has a Gematria value of 1555.

Another interesting geometrical feature of the Sea of Galilee can be found by considering again the circuit of its shoreline. As we have seen, the name Galilee means *circuit.*

Let's roll out this circuit of its shoreline into a straight line. That line would be 33 miles long.

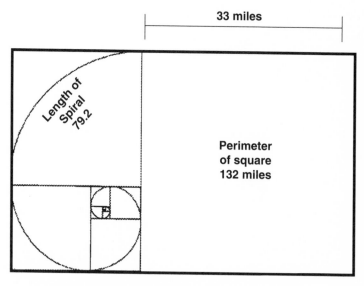

Considering this 33 miles as one side of a square, some magnificent numbers appear – numbers relating to Jesus Christ. The length of the Golden Spiral will be 79.2 miles. It is obviously pointing to the name Lord Jesus Christ, whose number in Hebrew Gematria is 792.

792 = Lord Jesus Christ
אלהא יהושע משיח

792 = Salvation
ישועות

But by the same method, let's take the square whose perimeter is 132 and roll it out as a straight line. If this is the measure of the long side of a Golden Rectrangle, the Golden Spiral drawn on its corners will be 316.8 – the number for Lord Jesus Christ in Greek Gematria.

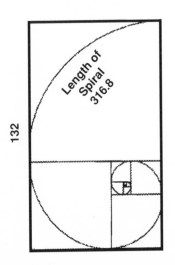

3168 = Lord Jesus Christ
Κυριος Ιησους Χριστος

The circuit of the circumference of the Sea of Galilee is 33 miles. This is exactly 264 furlongs. It is further identifying this sea as representing Jesus Christ, for this is the number value of *"Truth."* Jesus presented himself to his disciples as the very personification of truth, when he said, *"I am the way, the truth, and the life."* The word *"truth"* as is used in the New Testament, is the Greek word $\alpha\lambda\eta\theta\epsilon\iota\alpha\varsigma$ *(alethia),* and it has a Gematria value of 264.

He came to stand in the gap for sinful man, just as the Sea of Galilee stands in the gap of the Great Rift. He came *"in the likeness of sinful flesh"* as Paul told us in Romans 8:3, and this phrase has a Gematria value of 264.

We are considering the circuit of the shoreline of the Sea of Galilee – a distance of 33 miles. This circuit is not round. It is more probably egg-shaped. Its length is about 12 miles, and at its widest part about 6 miles – the length and width forming a cross 12 by 6 miles.

If we convert the proportions of this cross from miles to feet, it brings up numbers that speak loudly of salvation through the Lord Jesus Christ.

> **6 miles = 31,680 feet**
> **12 miles = 63,360 feet**

The number 3168 is the Gematria for the name Lord Jesus Christ, as it is spelled in the Greek text of the New Testament. The number 6336 is a palindrome of magnificent beauty, telling the story of salvation through the Lord Jesus Christ. Here are some of the evidences that these dimensions of the Sea of Galilee are of divine design.

6336 = This Jesus God has raised up, of whom we are all witnesses. (Acts 2:32)
τουτον τον Ιησουν ανεστησεν ο Θεος ου παντες ημεις εσμεν μαρτυρες

6336 ÷ 2 = 3168 = Lord Jesus Christ
Κυριος Ιησους Χριστος

6336 ÷ 3 = 2112 = A virgin shall conceive and bear a son and shall call his name Emmanuel (Isaiah 7:14)
ויולדת בן וקר את שמו עמנו אל
העלמה הרה

6336 ÷ 4 = 1584 = In Isaac shall thy seed be called
(prophetic of Jesus) (Romans 9:7)
εν Ισαακ κληθησεται σοι σπερμα

6336 ÷ 6 = 1056 = The joy of thy salvation (Psalm 51:12)
ששון ישעך

6336 ÷ 8 = 792 = He is salvation (Genesis 3:20)
ישועות

6336 ÷ 9 = 704 = Pierced (Revelation 1:7)
εξεκεντησαν

6336 ÷ 11 = 576 = Wells of salvation (Isaiah 12:3)
מעיני הישועה

6336 ÷ 12 = 528 = The key (the key to the Kingdom of
David, belonging to Jesus)
(Isaiah 22:22)
מפתח

6336 ÷ 16 = 396 = Salvation (Isaiah 12:3)
הישועה

6336 ÷ 18 = 352 = The Way (Jesus is the Way to life)
(John 14:6)
ηοδος

6336 ÷ 22 = 288 = It pleased the Lord to bruise him; he hath put him to grief (the sacrifice of Jesus) (Isaiah 53:10)

יהוה חפץ דכאו החלי

6336 ÷ 24 = 264 = Truth (Jesus being full of grace and truth) (John 15:26)

αληθειας

6336 ÷ 32 = 198 = The King in his beauty (King Jesus) (Isaiah 33:17)

מלך ביפיו

6336 ÷ 33 = 192 = The Lord of Glory (Jesus) (I Corinthians 2:8)

τον κυριον της δοξης

6336 ÷ 36 = 176 = Come to the water (water of salvation and life) (Isaiah 55:1)

לכו למים

6336 ÷ 44 = 144 = Everlasting (Jesus purchased everlasting life for all mankind) (Habakkuk 1:12)

קדם

Yes, this majestic peaceful sea, represents Jesus, who will be earth's *"Prince of peace."* It fills the gap of the Great Rift between God and men. It is the promise of life – indeed it represents the very payment for the forfeited life of Adam.

The circuit of its shoreline is 264 furlongs. Let's roll it out again into a straight line, and consider it as one side of a square, just as we did for the 33 miles. If this straight line of 264 furlongs is one side of a square, the perimeter of the square will be 1,056 furlongs. Again, project its Golden Proportion and trace a spiral on its corners, and the spiral will measure 633.6 furlongs.

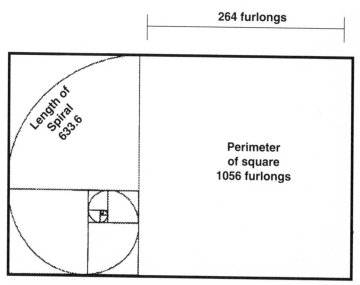

It was beside this life-giving sea that Jesus fed five thousand and, on a later occasion, fed four thousand. These are recorded in all four Gospels, however, John only mentioned

the feeding of the five thousand. On both occasions, there were many more that were actually fed, but the five thousand and the four thousand referred only to men. The women and children were in addition.

Feeding this many people, from a meager supply of bread and fish, was obviously a miracle. However the word used in the Greek text is best translated *"sign."* It is the word σημειον *(semeion)*, whose Gematria value is 383. It is a magnificent number, relating to the Golden Proportion. Thus it appears to be confirming the use of this amazing proportion as it relates to the Sea of Galilee and to Jesus Christ.

618

**Golden Rectangle
of "Sign"**

383

.618 Golden Proportion
383 Gematria for *semeion* (sign)

Jesus gave them two *"signs."* First, he fed five thousand men (and additionally their women and children). Second, he fed four thousand (and their women and children). He fed them with bread and fish.

A sign is pointing toward something that is the reality of what the sign pictures. To what was Jesus pointing by giving them these signs?

To begin, it is a known fact that Jesus is represented by both bread and fish. He is the *"bread from heaven"* that had been pictured by the manna which the Israelites ate while in the wilderness 40 years. He is also known by the symbol of the fish. If these two food items represent Jesus, then, in symbol, he gave them of himself to eat.

The first feeding was to 5,000. It is well known that the number 5 represents "grace." It would represent a time when the feeding would be by grace.

The second feeding was to 4,000. It is also well known that the number 4 represents "judgment." Thus it would represent a time when the feeding would be accompanied by judgment.

The age of "grace" began with the Day of Pentecost in the year A.D. 33, just ten days after Jesus ascended, and fifty days after his resurrection. It is the age of the development and the selection of the "Bride of Christ," culminating in her marriage to him. It is during this age that she "feeds" on him. He is her life-giver and life-sustainer.

The age of "judgment" is earth's great Millennium. But it should be mentioned that judgment does not necessarily mean punishment. It simply means the evidence is being brought before the great high Court. It is the time when Jesus (and his bride) will be feeding all mankind with that same

bread and fish -- representing him.

Many think of judgment as condemnation. The scriptures, on the other hand, present it as a time of learning righteousness. The prophet Isaiah said,

> *"When the judgments of the Lord are in the earth, the inhabitants of the world will learn righteousness."* (Isaiah 26:9)

The same prophet further identified the time of judgment with the establishment of righteousness in the earth. He said,

> *"Then judgment shall dwell in the wilderness, and righteousness remain in the fruitful field. And the work of righteousness shall be peace; and the effect of righteousness quietness and assurance forever. And my people shall dwell in a peaceable habitation, and in sure dwellings, and in quiet resting places."* (Isaiah 32:16-18)

First he fed the 5,000; second he fed the 4,000 – the total feeding was represented by 9,000. Nines have a very special place in the Sacred Code of Number, just as they have a very special place in pure mathematics. The number nine is the last of the digits, it represents finality, fulfillment, perfection, full accomplishment – wholeness. Mathematicians say you can do special things with nines that can be done with no other digits. Ancient mathematicians called it The Finishing Post, but Michael S. Schneider, in his delightful book *A Beginner's Guide to Constructing*

the Universe calls the number nine "The Horizon," implying there is something unknown beyond. Yes, there is something beyond, and the Bible calls it "eternity."

This concept of wholeness is shown in the first words of Genesis: *"In the beginning God"* has a Gematria value of 999. It speaks of His wholeness and completeness, even before He began the work of creation. The creation of Adam was in the "9 condition." He was in the condition of "eternity."

It is said of God that He is without beginning and without end – everlasting. This has often been illustrated by a circle, which also has no beginning nor ending. And isn't it interesting to find in the scriptures the Greek word περιαγω, which means *"go in a circle,"* whose Gematria value is 999. And isn't it interesting that Galilee means *"circle"* or *"to go in a circle."* How marvelous are the works of God!

Jesus, by giving this *"sign"* beside the Sea of Galilee, was illustrating the fact that he is the living bread, and he is the fulfillment of the symbol of the fish – both of which are for the feeding of all mankind. First he feeds his church, and the nourishment builds and develops those who become his bride. Secondly he feeds all the remainder of mankind – all those who died *"in Adam,"* thus nourishing and restoring to them all that was lost *"in Adam."* Yes, God's human family will be restored to the "9 condition."

This restoring of all mankind is illustrated by the Psalmist as being like *"silver refined in an earthen furnace."* This

has a Gematria value of 999. It will be the condition of the entire human race at the end of earth's great Millennium, when man and his earth will have come full circle from creation in perfection to full restoration and reconciliation with their Creator. It is a magnificent promise:

> *"The words of Jehovah are pure words, like silver refined in an earthen furnace, purified seven times. You O Jehovah shall keep them. You shall preserve them from this generation forever."* (Psalm 12:6 Masoretic Text)

The Sea of Galilee has apparently been placed in the topography of our earth to be a magnificent illustration of the life and death of Jesus Christ as the payment for the forfeited life of Adam. The payment has been placed into the hands of Divine Justice. Yet the full work of restoring man to all that was lost in Adam is yet future.

The Sea of Galilee is the payment of the price, yet the Jordan River, representing Adamic death flows through it and emerges again at its southern end, as a river, descending rapidly toward the Dead Sea.

Mt. Hermon

Lake Huleh

Sea of
Galilee

Dead Sea

5

Lower Jordan

The section of the river flowing from the Sea of Galilee to the Dead Sea is a long, low plain, runing from north to south and shut in by steep and rugged parallel ridges. The eastern ridge is fully 5,000 feet above the river's bed, and the western ridge about 3,000 feet. This section of the Great Rift is called The Plain of the Jordan.

This plain is about 6 miles wide at its northern end and gradually expanding to about 12 miles wide at the lower end – the Plain of Jericho.

The numbers, of course, immediately grab the attention, for they are the same as the length and width of the Sea of Galilee. This sea filled the gap at the northern end, and, if turned 90 degrees, would fill the gap at the southern end.

Within these high walls of the plain runs a deeper ravine through which the

river makes its tortuous course, now sweeping the western bank, and now the eastern, now doubling back, twisting and turning as if in reckless abandon, as it plunges toward its inevitable end, the Dead Sea.

During the course of its race to the Dead Sea, it plunges over 27 rapids and widens into 60 fording places. Until the time of the Roman occupation there were no bridges over the Jordan. The most used, and the one most mentioned in history was the ford opposite Jericho. Actually there were two fords there, with a small space of quiet river between them. Because of its much use by travelers, the Romans built a bridge there, for during the winter and spring months the high water made fording difficult if not impossible.

The straight line distance between its outflow from the Sea of Galilee to its disappearance into the Dead Sea is 64.8 miles; however, as the river flows, it covers a winding distance of about 200 miles. During this distance it drops in elevation 618 feet – the numbers of the Golden Proportion. When I saw this number I knew there would be far more to this than merely the random rovings of a muddy stream.

Driven by curiosity, and the desire to find its meaning, if there was one, I checked the descent of the entire river, from its beginnings at its three principal fountains to its entrance into the Dead Sea. Some magnificent numbers made their appearance.

Banias fountain is considered, by most Jewish writers, to be the official "source" of the Jordan, even though its two

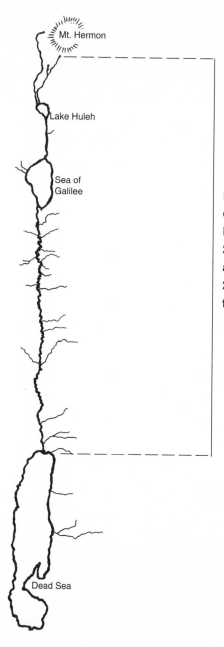

Mt. Hermon

Lake Huleh

Sea of
Galilee

Drop in
elevation
between
2,376
and
2,380
feet

Dead Sea

Lower Jordan 69

other fountains supply an abundant amount of its water. So I checked the descent in elevation from Banias to the Dead Sea. It is sometimes stated as 2,376 feet to 2,380 feet. Various authors give figures lying within this four foot tolerance. But these are interesting numbers that tell an amazing story.

The number 2376 at first puzzled me, because I had found that it is the Gematria value for the prophecy which Jacob spoke over his son Dan – *"... a horned snake on the path that bites the heels of the horse, and its rider falls."* This portion of the statement, in Hebrew, has a Gematria value of 2376. And Banias fountain is in the territory of Dan. What is the connection?

Upon further investigation, I realized that the Apostle Paul had used this same number (unknowingly, I'm sure) when he spoke of the resurrection, and the means of resurrection, Jesus Christ. He said:

> *"... Death is swallowed up in victory. O death, where is thy sting? O grave, where is thy victory? ... But thanks be to God who giveth us the victory through our Lord Jesus Christ."*
> (I Corinthians 15:54-57)

The last portion of this, from the Greek text, reads: *"the One giving us the victory"* and it has a Gematria value of 2376. That "One" of course is Jesus Christ, whom God sent to give us the victory over death.

Suddenly the beauty of it shone as a bright light,

illuminating the meaning of the number. Jesus was the *"Lamb slain from the foundation of the world"* – long before Adam was created. And even though the waters issuing forth from Banias fountain are the pure waters of life, given to Adam before he sinned, yet in the foreknowledge of God, provision was made for the event of his sin, which He knew would soon follow.

2376 = A horned snake on the path that bites the heels of the horse, and its rider falls (Genesis 49:16)

2376 = The one giving us the victory (I Cor. 15:57)

The entire flow of the river, from Banias fountain to the Dead Sea is a descent in elevation of 2,376 feet. It tells of the anticipated need of a redeemer, even before Adam sinned, and the sending of that Redeemer to recover Adam and all who would be born of Adam – God's entire human family.

The other figure given for the descent from Banias to the Dead Sea is 2,380 feet. The reason for the difference is the changing levels of the Dead Sea over time. This descent of 2,380 feet appears to be prophetic of the resulting benefit of the resurrection of all mankind from the downward course

of the river (Adamic death), and the establishment of divine government in the earth. This number is found in the Gematria of the prophecy of Jeremiah:

> *"They shall call Jerusalem the throne of the Lord and all nations shall be gathered unto it, to the name of the Lord, to Jerusalem."* (Jeremiah 3:17)

The city of Jerusalem is at the same latitude as the place where the waters of Jordan empty into the Dead Sea.

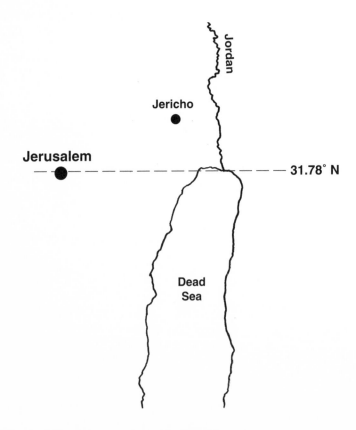

It was not by random chance that the city of Jerusalem was built at this latitude. It was part of the great plan of the Creator. Jerusalem represents the seat of Divine Government. It is situated at the same latitude as the entrance into the Dead Sea. Why? What is the picture?

This will be discussed in detail in later chapters, but be it sufficient now to recognize it parallels the entrance of mankind into the great reservoir of death, as if to say "I have power over death." It speaks of a hope of recovery from death. Not just a return, but of a full recovery from the effects of sin and death, into the blessed peace and security of Divine Government, whose laws will be written into the heart of man.

> *"After those days, saith the Lord, I will put my law in their inward parts, and write it in their hearts; and will be their God, and they shall be my people. And they shall teach no more every man his neighbor, and every man his brother, saying, Know the Lord; for they shall all know me, from the least of them unto the greatest of them, saith the Lord: for I will forgive their iniquity, and I will remember their sin no more."*
> (Jeremiah 31:33-34)

A short distance upstream from the Dead Sea are the two fords opposite Jericho. It was here that Joshua led the Israelites across the Jordan and into the Promise Land – an event known to most people of today, but regarded by many as a fanciful tale. However, there is nothing fictitious about

it. Just as sure as the Bible is the word of God, it really happened. And it bears some amazing Gematria. Let's look at the scriptural account.

> *"And it happened, as the people moved from their tents to cross over the Jordan, and as the priests carried the ark of the covenant before the people, and as those carrying the ark came into the Jordan, and the feet of the priests carrying the ark were dipped in the edge of the waters – and the Jordan was full, over all its banks all the days of harvest – that the waters stood still; those coming down from above rose up into a heap, very far above, at the city of Adam, which is beside Zaretan; and those going down by the sea of the Arabah, the salt sea, were completely cut off; and the people passed over opposite to Jericho. And the priests bearing the ark of the covenant of Jehovah stood firm on dry ground in the middle of the Jordan; and all Israel crossed over on dry ground until all the nation had completely passed over the Jordan."* (Joshua 3:14-17)

Some have suggested that this was not physically possible, however, it should be remembered that this was at a place on the Jordan where the water was normally shallow and rocky, with a solid riverbed, being at two fords where quiet waters flow between. It was a much-used fording place, there being a wadi on each side of the river, affording easy access from the mountains on either side.

The Plain of the Jordan was very expansive here, affording passage for a very large number of people. It was on this plain, at a place called Beth-peor, that God had secretly buried Moses a few days before.

Moses had brought the Israelites through the desert for a long space of 40 years, but he, himself, was not permitted to cross over into the Promise Land. Instead, God had told him to climb to the top of Pisgah, and it was from there that he was given a view of the good land which God had promised. But He had said, *" Thou shalt not go over this Jordan,"* (Deuteronomy 3:27).

So Moses went to the top of Mt. Nebo, which is a peak of the Pisgah range – the range that was also called Abarim. From there he saw a panoramic view of the good land that God had promised. The prospect from Mt. Nebo was magnificent. He could see the mountains rise on the far side of the Dead Sea and the fertile land that faded into the faint outline of the Mediterranean, blending into sea and sky in the distant haze. As his eyes turned toward the north, he could see Mt. Tabor, and still further he saw the dark forests between the hills, bold and undulating, with the deep sides of mountains, here and there whitened by cliffs. And beyond it all, blending into the distant sky, was the regal snowy peak of Mt. Hermon, reflecting the sunlight. And to his far right, his eyes followed the course of the Jordan through its deep green valley. This was the goal for which he had labored 40 years to acquire, but now he knew that he

would not be permitted to cross over. And so he died there, and God buried him at the foot of the mountain, at Beth-peor, on the plains of Moab. It was down by the Jordan, across from Jericho.

Before going up into the mountain, Moses had commissioned Joshua to be the new leader. The name Joshua means "saviour."

Moses was a type, or illustration of Jesus in his position as "son of the law." Indeed, Moses had been the one to receive the Law during their long trek through the desert. But now they must cross this Jordan, and they needed a new leader – one who would still picture Jesus – but one who could represent Jesus as the means of salvation. For the people must cross over the river which pictured death, in order to receive the good land that had been promised. They needed to be "saved" from death – or perhaps more properly, they needed to be saved *through* death.

So Joshua commanded the priests to carry the Ark of the Covenant into the middle of the river. As soon as their feet touched the water, the waters began to back up. As the priests reached the middle of the river, they were standing on dry ground. And be it remembered, this was springtime, and the melting snows of Mt. Hermon had filled the river, causing it to flood beyond its normal banks. At such times, the fords were impassable. It was called *"the swelling of Jordan."*

But the Hebrew word used here for *"swelling"* does

not mean literally flooding. It is an idiom, or figure of speech, and it carries the thought of being proud and boastful. The *"swelling of Jordan,"* carries the thought of the "proud waters" going their own way without constraint or control, perhaps even somewhat defiant of authority. But when the priests stepped into the proud waters, they shrank from their flow and retreated all the way back to the city of Adam.

From this location on the river to the city of Adam was a straight-line distance of 18 miles. Convert the miles to yards, and we find it bears the number that represents the Lord Jesus Christ – 3168.

18 miles x 5280 = 95040 ÷ 3 = 31680 yards

3168 = Lord Jesus Christ

He is the means by which the proud and wanton tide of death is rolled back all the way to and, including, the man Adam. But why did the rolling back of the waters begin when the priests carried the Ark of the Covenant into the river?

The symbol is beautiful. During the 40 years they were in the desert, the Ark of the Covenant was the place where they sprinkled the blood of Atonement. Although it had been

the blood of animals, it represented the blood of Jesus. The picture is quite clear: it's as if the sacrifice of Jesus were standing in the middle of the river, stopping the forward flow of death and rolling it all the way back to include all who had been born and died in Adam. The prophet Isaiah stated it this way:

> *"He shall see the travail of his soul, and shall be satisfied: by his knowledge shall my righteous servant justify many; for he shall bear their iniquities."* (Isaiah 53:11)

This verse has a total Gematria value of 3168, and its first phrase, *"He shall see the travail of his soul"* has a Gematria value of 792. And, we have seen that the name Lord Jesus Christ, when spelled in Hebrew, has a value of 792. The identification is unmistakable. There is no way the numbers could be random. They are precise and they are specific.

The global effect of this payment for sin is also unmistakable, for the numbers are the dimensions of our earth. The mean diameter of earth is 7,920 miles, and a square drawn around the earth will have a perimeter of 31,680 miles. It tells us that the life-giving effect of the blood of Jesus, the price of atonement, completely surrounds and engulfs our earth, like the sunlight that completely bathes our planet every twenty-four hours. It was sent from the love of God. It rolled back the relentless waters of death.

From the place where the priests stood in the river, the

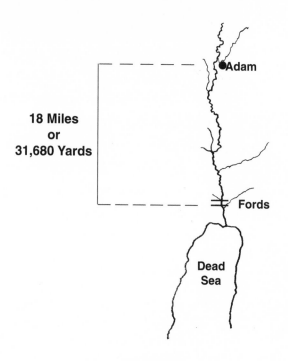

18 Miles
or
31,680 Yards

Adam

Fords

Dead
Sea

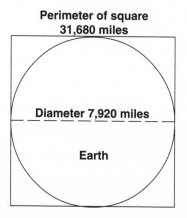

Perimeter of square
31,680 miles

Diameter 7,920 miles

Earth

3168 = Lord Jesus Christ (Greek)
792 = Lord Jesus Christ (Hebrew)

water that was there continued flowing downward, to the Dead Sea, leaving the river dry, all the way from the city of Adam to the Dead Sea.

Remember, the descent in elevation of the river from the Sea of Galilee to the Dead Sea is 618 feet. It is the smaller number of the Golden Proportion. However, the rolling back of the water bears the larger number of the Golden Proportion, 1.618. That these two representations of the Golden Ratio should be shown here is astounding. It could not be by random chance. It is part of the obvious plan of the river.

1618 = And the waters stood still, those coming down from above rose up into a heap very far above, at the city of Adam. (Joshua 3:16)

The Ark of the Covenant, being held in the middle of the river, represents the blood of atonement, offered by Jesus, as he hung upon the cross, and his blood spilled out upon the ground. Isaiah 53:5 tells us *"By his wounds we are healed."* It was the price of atonement. The means of atonement is here described as being *"by his wounds,"* which has a Gematria value of 618, the Golden Proportion.

Zechariah spoke of those wounds. He called it *"the wounds between your hands"* (Zechariah 13:6) which also

has a Gematria value of 618. Those hands were nailed to the cross.

618 = by his wounds, בחברתו
(Isaiah 53:5)

618 = The wounds between your hands,
המכות האלה בין ידיך
(Zechariah 13:6)

Because the waters representing death through Adam were now absent from the river bed, from the city of Adam all the way down to the Dead Sea, there was ample room for the entire people of Israel to cross over. But the act of crossing over was symbolic of passing through the death condition and into a condition of new life. They could now enter into the land which Moses had been permitted to see from the top of Pisgah. It was all made possible by the priests standing in the middle of the river, holding the Ark of the Covenant – the symbol of the means of atonement.

More than fourteen hundred years later, the real "means of atonement" stood in the middle of the Jordan, in the same place where the priests had held the Ark of the Covenant. It was not a random choice of location. It was pre-designed. It was part of the plan. Jesus came to John to be baptized, at

the fords of Bethabara, 18 miles south of the city of Adam. It was in fulfillment of the type. He allowed John to put him under the water, representing death. It was a symbol of his life blood being poured out, just as the blood of atonement had been placed on the Ark of the Covenant.

It was not by accident that the place was named Bethabara – *the house of crossing.* This name is a composite of two Hebrew words: *beth,* meaning "house," and *abar,* meaning "to cross over." Some translations call it the *"ferry-house,"* and it just might have been not only a ford, but a place where travelers could cross over in a boat when the waters were high. It was in reality and in symbol, a place of "crossing over."

This was the same crossing where Gideon had defeated the Midianites. He had routed them from their camp in the valley of Jezreel, which is the same as Armageddon, and he and his little band of 300 men chased them east and south to the Jordan, where they had set up an ambush at the *"house of crossing."* It was here, at the rock of Oreb, Israel experienced a victory which went down in history.

Isaiah prophesied concerning the time when Israel's enemies would come against her in an attempt to annihilate the nation. But he gave the assurance that God would strike down those enemies as he struck the Midianites at the rock of Oreb. He said:

> *"The Lord Almighty will lash them with a whip,*
> *as when he struck down Midian at the rock of*

*Oreb; and he will raise his staff over the waters,
as he did in Egypt."* (Isaiah 10:26)

When He raised his staff over the waters, the sea parted,
and the Israelies had been saved from the Egyptians who
intended to bring them back into bondage. Isaiah used this
as an illustration of the victory that Israel would experience
over her enemies in Armageddon. The victory for Gideon
was at the *"house of crossing."* It was a place of victory for
Israel and a place of defeat for her enemies. Perhaps it is a
picture of the "crossing over" that Israel will experience
when Jesus, their Messiah, will save them from the modern
day "Midianites" – the Arab nations. That "crossing over"
will include their recognition of their Messiah.

*"On that day I will set out to destroy all the
nations that attack Jerusalem. And I will pour
out on the house of David and the inhabitants of
Jerusalem a spirit of grace and supplication.
They will look upon me, the one they have
pierced, and they will mourn for him as one
mourns for an only child, and grieve bitterly
for him as one grieves for a firstborn son."*
(Zechariah 12:9-10)

After Gideon won the victory over the Midianites, the
people of Israel wanted to make him ruler over them. Like-
wise, when their long-awaited Messiah, Jesus Christ, saves
them from the enemies who have vowed to annihilate them,
they will not only mourn for him, but they will recognize

him as the promised ruler on David's throne, and will desire him to rule over them.

The relationship between Gideon and Jesus Christ is not only obvious from the scriptural record, but it is also apparent from the Gematria of their names.

> **133 = Gideon, גדעון**
> **1330 = Christ, Χριστον**

In the Hebrew text, Bethabara is spelled as two words – Beth Barah, ברה בית. It has a Gematria value of 619. It has been suggested that the lower Jordan in some way is represented by the Golden Proportion, .618. This is emphasized by the fact of its descent in elevation from the Sea of Galilee to the Dead Sea, a drop of 618 feet. Now we find that Beth Barah, *the house of crossing*, bears the number 619. Is there any connection? Perhaps. The ancient use of Gematria in the Hebrew language allowed for a difference of 1 number. When one number is either added or subtracted from a total, this manipulation was called "Colel," and was an acceptable rendering of the numbers. I have purposely tried to avoid the use of Colel because it might be confusing to the reader. It might give the reader the suspicion that I am "cutting and fitting" to make the numbers match. However, this spelling of Beth Barah with its number 619 might be an

acceptable reference to the Golden Proportion.

Bethabara, *the house of crossing*, is 18 miles (in a straight line) downstream from the city of Adam. It is probably also part of the plan that Bethabara, in the New Testament, has a Gematria value of 81, the mirror opposite of 18. Wherever these two numbers, 1 and 8, are found in the Gematria of the scriptures, it bears taking an inquiring look. The number 1 represents "beginning" and the number 8 represents "new beginning." Hence, they also represent the Beginner and the New Beginner. Jesus was both. We are told in the Gospel of John that *"without him there was nothing made."* He was the active agent of the Father in all the works of creation. He had been the first creation of the Father. He was number 1. But he is also the one providing the restoration of life to all who were lost in Adam, bringing to mankind a "New Beginning." Thus he is represented by the 1 and also by the 8.

At Bethabara, *the house of crossing over,* he provided the means by which all mankind can "cross over" from Adamic death into new life. This was emphasized by the appearance of a dove lighting upon him when John brought him up out of the water. The *"dove"* has a Gematria value of 801. In the book of Revelation he identifies himself as the *"alpha and omega."* They are the first and last letters of the Greek alphabet, bearing the numbers 1 and 800. The relationship of Bethabara to the place where the dove came upon Jesus as he came up out of the water does not appear

to be random numbers – they appear to be pre-planned, and with a purpose.

81 = Bethabara, *Βηθανια*
801 = Dove, *περιστερα*
801 = Alpha (1) Omega (800)

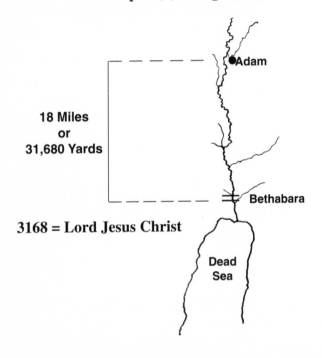

Bethabara, with its number 81 (9 x 9), or 619 (Golden Proportion?) was the fording place between the wadis which came down on the east and west side of the river. In the days of Gideon there was a circle of stones about a mile from the river's edge. These stones had been placed there at the time

when Joshua led the Israelites across the Jordan. The place was called Gilgal, which is a Hebrew word meaning *"circle"* or *"rolling."* Its Gematria value by multiplication is 81.

ג ל ג ל

30 x 3 x 30 x 3 = 8100

Zeros are usually dropped when multiplying Gematria values.

"And Joshua said unto them, Pass over before the Ark of the Lord your God into the midst of Jordan, and take you up every man a stone upon his shoulder, according to the number of the tribes of the children of Israel: that this may be a sign among you, that when your children ask their fathers in time to come, saying, What mean ye by these stones? Then ye shall answer them, that the waters of Jordan were cut off before the Ark of the Covenant of the Lord; when it passed over Jordan, the waters of the Jordan were cut off: and these stones shall be for a memorial unto the children of Israel forever ... that all the people of the earth might know the hand of the Lord, that it is mighty; that ye might fear the Lord your God forever." (Joshua 4:5-24)

These were no small stones, for the instruction was for each man to carry it upon his shoulder. The stones were carried to a small hill and there placed in a circle. They were to be for a memorial of their deliverance from Egypt, from their homeless wandering in the wilderness, and the miraculous crossing of the Jordan on dry land.

> *"And the Lord said unto Joshua, this day have I rolled away the reproach of Egypt from off you. Wherefore the name of the place is called Gilgal unto this day."* (Joshua 5:9)

That statement was a play on words, which is quite often found in the Old Testament record. The word Gilgal literally means a wheel or that which is circular, but it was also used to mean *"rolling away"* or a *"whirlwind."*

The *"rolling away"* of the reproach of Egypt, and the placing of the stones in a circle as a wheel, appropriately gave the place the name of Gilgal.

The twelve stones of Gilgal remained as a memorial for over 2,000 years. Jerome, once known as the "patron saint of Christian and ecclesiastical learning" mentioned that the site of the camp of Gilgal and the twelve stones was still distinguishable in his day (4th century A.D.). He said it was about two miles from Jericho. By the 7th century A.D. a church had been built at the site, but the stones were said to still stand.

Undoubtedly, when Jesus walked down to the Jordan to be baptized, he passed this circle of stones.

It is appropriate that Bethabara, *the house of crossing over,* be the place where Jesus was baptized, for it symbolized his going down into death as the price with which to redeem Adam, and all of Adam's children. It therefore is the place of *crossing over* for all mankind.

Many years after Joshua led the Israelites across Jordan, there was another crossing over on dry land – it was another rolling back of the river at Bethabara. This time it was for two men – Elijah and Elisha.

The two had walked from Jericho, past the Gilgal stones and to the west shore of the Jordan. To cross would have meant to ford the river, wading through its shallow water. Elijah knew he must cross this Jordan to be on the east bank, where Moses had been buried. But, instead of stepping into the water, he took his cloak which had been wrapped around him, rolled it up, and struck the water with it. As the two men stood there, they watched the waters part, leaving a dry path through which they could cross.

> *"Elijah took his cloak, rolled it up and struck the water with it. The water divided to the right and to the left, and the two of them crossed over on dry ground."* (2 Kings 2:8)

On the east bank of the river they walked along together, and suddenly the appearance of a chariot made of fire, and horses of fire came between them. Then, before Elisha could realize what was happening, a whirlwind caught Elijah up and he disappeared from sight. His cloak fell onto Elisha.

The word *"whirlwind"* used here in the Hebrew text, is *caar (saw-ar)*, סַעַר, and it has a Gematria value of 330. Amazing!

We saw in Chapter 4 (page 35) that the circuit of the shoreline of the Sea of Galilee is 33 miles. What a magnificent number! It represents Jesus, the *"holy and just one"* who through much *"pain"* paid the *"atonement"* price for the sin of Adam.

330 = The holy and just One
330 = Atonement
330 = Pain

330 = Whirlwind

Elijah was in the fire, in the whirlwind, and it took him up and out of sight. What a grand and sublime picture! Elijah, whose name means *"My God is Jehovah,"* is here an illustration of Jesus, the *"only begotten son of God,"* paying the price of sin and being taken up into the presence of God.

The cloak, with which he parted the waters of the Jordan, fell on Elisha, whose name means *"God is salvation."*

Elisha rolled up the cloak and struck the waters, which parted as he walked back across to the west bank of the Jordan, just as Jesus would, many years later, come up out

of Jordan after his baptism – it pictured his coming up out of death. After the resurrection of Jesus he said, *"All power is given unto me in heaven and in earth."* (Matthew 28:18) Elisha now pictured Jesus in power and glory.

The company of prophets who were watching said: *"The spirit of Elijah is on Elisha."* The Gematria for this statement clearly indicates that Elisha now represented the glorified Jesus.

(Read from right to left)

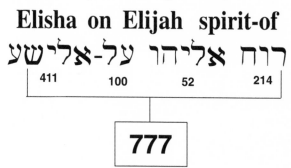

Elisha on Elijah spirit-of

רוח אליהו על-אלישע

411 100 52 214

777

He is exalted
in power and justice
(Job 37:23)

שגיא כח ומשפט

435 28 314

777

Elisha stepped out of the river bed onto the west bank, walking past the Gilgal stones, and continued the two miles from there to the city of Jericho. When he reached Jericho the men of the city said to him, *"... this town is well situated, as you can see, but the water is bad and the land is unproductive."*

They were referring to the spring just outside the town of Jericho which should have supplied the city with water, but its waters were polluted and caused the people to be sick, making it also unsuited for irrigation.

Elisha, took a *"new bowl"* filled with salt and poured it into the spring.

> *"Then he went out to the spring and threw the salt into it, saying, 'This is what the Lord says, 'I have healed this water. Never again will it cause death or make the land unproductive.' And the water has remained wholesome to this day, according to the word Elisha had spoken."* (2 Kings 2:21)

Let's pause a moment and see the panoramic view of the story:

1. **Elisha pictures Jesus in power and glory.**

2. **Jericho pictures man's governments, which have held sway over the human race for 6,000 years.**

3. **Elisha walked one mile from Jordan to Gilgal, and two additional miles to Jericho, where his first act was to heal the poison water, representing 3,000 years from the atonement offering of Jesus to the complete healing of the poison of man's governments.**

The poisonous effects of man's governments have made themselves manifest down through history as:

- Oppression
- Exploitation
- Slavery
- Murder
- Robbery
- Death

The purpose of Christ's Millennial Kingdom is to overthrow man's governments and establish Divine Government in the earth. This includes the complete eradication of the effects of man's governments from the hearts of men. It is the great "third day" from the time when Jesus purchased all that Adam had lost.

But in the illustration of Elisha walking from Bethabara to Jericho, the distance is divided into a space of one mile and a space of two miles. It suggests that after a space of 2,000 years from the atonement sacrifice of Jesus, he will begin the healing of the waters of Jericho, but it will

require the additional 1,000 years until all the effects of the "poison water" will be completely removed from mankind.

It is then that the promise, recorded by Isaiah, will be fulfilled:

> *"Ho everyone that thirsteth, come ye to the waters, and he that hath no money; come ye, buy, and eat; yea, come, buy wine and milk without money and without price."* (Isaiah 55:1)

The Apostle John recorded the same invitation:

> *"... and let him that is athirst come. And whosoever will, let him take the water of life freely."* (Revelation 11:17)

Yes, it is a free gift. Jesus paid the price, and we receive the gift of life.

This story suggests the interpretation that Elijah, crossing the Jordan at Bethabara, from west to east, being in the fire of the chariot and horses, and going up in the whirlwind; Elisha receiving the cloak, crossing the Jordan again at Bethabara from east to west – is a real-life allegory telling the story of Jesus being baptized in the Jordan (west to east), followed by the fiery trials of his 3 1/2 year ministry and the agony of the cross, but coming up out of death (crossing from east to west). The many miracles which Elisha performed following his crossing the Jordan (east to west) are beautiful illustrations of the blessings which the glorified Jesus will perform for all mankind during earth's great

Millennium: the healing of the poison waters, the raising of the dead, and the cleansing of Naaman's leprosy.

The story of the healing of Naaman is rich with meaningful symbolism. Naaman was a Gentile – the commanding general of the army of Syria (Aram) to the north of Israel. He had leprosy. His wife's handmaid, a young Israelite girl, offered a suggestion to him that there was a prophet in Israel who could heal his leprosy. Since there was no known medical cure for leprosy, Naaman took heed to the maid's suggestion, and amassed a royal caravan and traveled to Israel in search of this famed healer.

In this story, Naaman is a picture of the power and authority of the governments of man. But those governments have a fatal illness – they have leprosy, which is an illustration of the sin of self will (I'll do it my way because I am in control). Since this event happened after Elisha had crossed the Jordan (east to west), the time setting for the fulfillment would be earth's great Millennium, when Divine Government will be established in the earth.

The little Israelite girl would, of course, picture Israel, where Divine Government is being established at Jerusalem. And we are told by the prophets that at the time when the Kingdom of righteousness is being established in the earth, the *"word of the Lord"* would go forth from Jerusalem.

To be healed, Naaman would have to go to Israel. For the nations to receive healing, they will have to "go to Israel" also.

So Naaman packed his caravan and headed for Israel. When he arrived he went to the king, and offered him *"ten talents of silver, six thousand shekels of gold and ten sets of clothing,"* in payment for being healed of his leprosy.

The king of Israel, Joram, sent him to Elisha. Elisha refused to accept the money and the clothing.

We have been assured that salvation is free. The price has already been paid by the offering of Jesus. Naaman had attempted to "buy" his healing from Elisha, but the payment was refused. It is awesome to realize that the Gematria value for the *"ten talents of silver, six thousand shekels of gold and ten sets of clothing"* is 3330.

In chapter 2 it has been shown that the number 333 refers to the pure fresh waters from the snow on Mt. Hermon which comes bubbling up in the three springs of Hasbani, Banias and Leddan, feeding Lake Huleh. It is a beautiful illustration of the pure and perfect life that was first given to Adam. Naaman had attempted to buy healing with the same price, but the price was refused. There is no way we can purchase salvation. It has already been paid.

Elisha, at the time, was living in the hill country above and to the west of Jericho. His response to Naaman was to *"Go, wash yourself seven times in the Jordan, and your flesh will be restored and you will be cleansed."* (2 Kings 5:10)

Naaman's pride had been violated, and he became angry. He said *"Are not Abana and Pharpar, the rivers of Damascus, better than any of the waters of Israel? Couldn't*

I wash in them and be cleansed?" He left Elisha in a rage.

Afterward, some of his servants came to him and convinced him that he should indeed do just as Elisha had instructed. So Naaman gave up his "self will" and did the will of Elisha. He and all his entourage went down to the Jordan.

The record in the Bible does not specifically say that he went to Bethabara. But logic, and the layout of the land suggests it was the likely place. Elisha was dwelling, at the time, in the hill country west of Jericho. To get to the Jordan would require taking the road to Jericho. From there the much-used road would take them to *"the house of crossing over."* Naaman would have entered the river in the same place where Elisha had come back across – the same place where Joshua had led the nation of Israel across – and the same place where, many centuries later, Jesus would be lowered beneath the water, symbolizing his going into death and paying the price of Adamic sin.

Naaman washed seven times, and came up out of the water clean. His leprosy had gone. He had been healed. The Hebrew text uses the word ויטהר, *"And he became clean."* It has a Gematria value of 230. The number 23 in the Gematria of the scriptures carries the meaning of both death and life. Naaman, with the fatal disease of leprosy, went down into the Jordan, and came back up healed. His leprosy was gone – his sin of self will had been healed. He is a very appropriate illustration of the Gentile nations of earth who

have, for 6,000 years, been ruling by their own selfish methods, not looking to God for their instruction, but doing it "my way."

The attempt to do it "my way" goes all the way back to the Garden of Eden, when God gave specific instructions to Adam, but instead, Adam did it "my way." Dominion – the right of rulership – had been given to Adam. As a result of Adam's sin, the rulership of earth has become increasingly corrupt. Its legacy is oppression, exploitation, slavery, murder, robbery, and death.

Naaman, as the military commander of a Gentile nation, is a fitting illustration of the entire Gentile rulership of the world. But they will be conquered and overthrown by Divine Government. Psalm 2 is a graphic description of this transfer of rulership. God's reply to their refusal to obey, is:

> *"I have installed my King on Zion, my holy hill.... therefore, you kings, be wise, be warned, you rulers of the earth. Serve the Lord with fear and rejoice with trembling."*

The prophet Zechariah gave us the assurance that this transfer of allegiance will indeed happen. After their failed attempt to fight against Divine Government, they will submit. They will then be healed of their "leprosy."

> *"Then the survivors from all the nations that have attacked Jerusalem* (Divine Government) *will go up year after year to worship the King, the Lord Almighty, and to celebrate the Feast of Tabernacles."* (Zechariah 14:16)

Why does it specifically state they will celebrate the Feast of Tabernacles? Were there not seven feasts to which the people of Israel were responsible? Yes, but there is great significance in the fact that here, when the Gentile nations finally seek the blessings of Divine Government, it is said they would celebrate the Feast of Tabernacles.

Three of those seven feasts were very special, in that all the males were commanded to present themselves to God at the temple. This required that they travel from distant places where they lived, and come to Jerusalem to make the presentation at the temple. Thus, these three festivals came to be known as the "Pilgrim Festivals." These three special festivals were Passover, Pentecost and Tabernacles. They represent three long periods of time, each ending in a special presentation to God. Thus they are called the Passover Age, the Pentecost Age, and the Tabernacles Age.

The presentation at the end of the Passover Age was Jesus. He offered up himself to God as the payment for the sin of Adam. The presentation at the end of the Pentecost Age will be the complete true church, the bride of Christ, who, upon completion, will be presented to the Father. And, the presentation at the end of the Tabernacles Age will not only be the submission of man's governments to Divine Government, but it will also be the individual presentation of each member of God's human family. It will be a willing offering of each one of them to their God, whom they will have come to know and love.

These three Pilgrim Festivals are a picture of the complete work of redemption and restoration of man, ending at the beginning of God's Great Eighth Day.

| Passover Age | Pentecost Age | Tabernacles Age |

Passover Age: Redemption promised and paid
Pentecost Age: Call to the wedding
Tabernacles Age: Divine Government established in the earth

If these three ages of time bring an ending to man's 7,000 years, where do they begin, and do they include the entire span of man's time, culminating in the 8th day – eternity?

No! These three epochs of time account for 4,480 years of man's 7,000. The remainder is a period of 2,520 years. Since these three Pilgrim Festivals represent three periods of time, ending at the conclusion of man's 7,000 years, it obviously suggests that there was a special period of time at the beginning of man's "day" occupying a space of 2,520 years. Does the Bible give us evidence of this space of time?

Yes! The Bible alone, without help from elsewhere, gives us a contiguous record of time from the sin of Adam to the offering of the first Passover Lamb. It is a span of 2,520 years.[1]

1 See *Time and the Bible's Number Code,* Bonnie Gaunt, pp 189-196.

It is well known that the period of time between the sin of Adam and the great Flood was 1,656 years, and from thence to the year when the Israelites left Egypt was 864 years, making a total of 2,520 years from the sin of Adam to the offering of the first Passover lamb. The Apostle Paul identified this period of time as *Death reigned from Adam to Moses,"* (Romans 5:14).

"Death reigned from Adam to Moses" 2,520 years	
Adamic sin to great Flood 1656 years (864 + 792)	Flood to first Passover 864 years

The number 864, representing God, and the number 792, representing the Lord Jesus Christ are the years between the sin of Adam and the time when the great Flood came upon the earth. But another 864 years brought mankind to the place where the typical Lamb was slain – the promise of atonement for Adamic sin.

$$
\begin{array}{r}
864 \\
792 \\
+\ 864 \\
\hline
2,520
\end{array}
$$

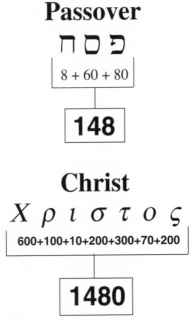

> **From the killing of the first Passover lamb to the death of Jesus on the cross 1,480 years**

Passover

כ ס ה

| 8 + 60 + 80 |

148

Christ

$X \rho \iota \sigma \tau o \varsigma$

| 600+100+10+200+300+70+200 |

1480

The 1,480 years from the type to its fulfillment is the span of time which can very appropriately by called the Passover Age. The Apostle Paul summed it up with these succinct words: *"Christ, our Passover, is sacrificed for us."* (1 Corinthians 5:7)

Just fifty two days after Jesus hung on the cross, a very special event took place. It was the day of Pentecost – another festival where all the males were to present them-

selves to God at the temple. But this time, as the disciples of Jesus were gathered together a special manifestation of the Holy Spirit came upon them. It empowered them to do things that ordinary men cannot do. It was an "anointing" of the Spirit of God. In reality it was the espousal of the bride of Christ – the legal engagement of a union that would take place a set time after. It began the Pentecost Age.

The association of Pentecost with a wedding began soon after the Israelites left Egypt, for the covenant between God and Israel, given to Moses on Mt. Sinai at the time of Pentecost, was indeed a marriage covenant. Israel, however, broke that covenant, and the union ended in divorce.

But God has promised that when Israel returns to Him in faithfulness, He will re-marry her.

In the meantime, another espousal and wedding has been planned – it is the marriage of Jesus and his bride.

> *"Let us be glad and rejoice, and give honour to him: for the marriage of the Lamb is come, and his wife hath made herself ready. And to her was granted that she should be arrayed in fine linen, clean and white; for the fine linen is the righteousness of saints."* (Revelation 19:7-8)

It is the long-awaited wedding day of Jesus and his bride.

Since the espousal was on a day of Pentecost, perhaps the wedding will be on a day of Pentecost – the great wedding day – but we are not talking about the "type" but the

"antitype." The counting of the days from the Firstfruits (the offering of Jesus) to Pentecost was 49 days, followed by the day of Pentecost. In the antitype, each of these "days" finds itself to be a period of 40 years. Thus the counting of the days from Firstfruits to Pentecost would be a span of 1,960 years, followed by the antitypical "day" of Pentecost, which would also be 40 years.

Counting the "days" from the day of Firstfruits, in which Jesus presented the merit of his sacrifice to God, in the year A.D. 33, the span of 1,960 years would bring us to the spring of 1993. Thus bringing us to the great antitypical "day" of Pentecost, which would begin in the spring of 1993 and end in the spring of 2033. This is the great wedding day. I say "great" because two weddings take place. First, Jesus and his espoused bride are joined as one, and second, the nation of Israel is re-married to God.

Thus the spring of 2033 marks the end of the great Pentecost Age and the beginning of the Tabernacles Age.

Pentecost Age 2,000 years

40 years

1,960 + 40 = 2,000 years

**Antitypical Day of Pentecost
the great Wedding Day**

The seven-day Feast of Tabernacles was a time of great joy. One of the rituals of that feast was the "drawing of water." It symbolized the drawing of the water of salvation – the water of life.

The water of life had originally come down from Mt. Hermon and filled Lake Huleh, representing the purity of life that had first been given to Adam. But as the water outflowed from this pure lake, it plunged into the Great Rift Valley, representing the rift between God and man at the time of the sin of Adam.

During the Feast of Tabernacles, a procession would go down to the Pool of Siloam, led by a priest who would draw water from the spring. As he was drawing the water, the people would shout: *"With joy shall ye draw water from the wells of salvation."* It pictured the healing work of earth's great Millennium – the antitypical seven-day Feast of Tabernacles.

Another ritual performed during the Feast of Tabernacles was the "illumination." It was the lighting of the candelabra. It is a fitting symbol of the enlightenment that will come to all mankind during the Millennium.

> *"They shall all know me from the least of them unto the greatest of them, saith the Lord: for I will forgive their iniquity, and I will remember their sin no more."* (Jeremiah 31:34)

The Feast of Tabernacles was a happy time – a time of giving gifts to one another, and of singing and rejoicing. Its

antitype will be likewise a time of great rejoicing, for it will be a time of the bringing together of all mankind under the peace and security of Divine Government.

| Tabernacles Age 1,000 years 2033 to 3033 | Great 8th Day. Eternity |

Another name for the Feast of Tabernacles was the *Feast of Ingathering,* because it was in the autumn of the year at the culmination of the grape harvest. It beautifully pictures the "ingathering" of all mankind into God's great harvest – the harvest of His beloved human family.

The washing of Naaman seven times in the Jordan at the *"house of crossing over,"* is a magnificent picture of the healing of all mankind (rulers and common people) during the antitypical seven-day Feast of Tabernacles. Naaman came up out of the Jordan clean. His deadly disease of leprosy had been completely healed.

This one geographical spot on the Jordan, as it descends from the Sea of Galilee to the Dead Sea, is, in symbol, the place where atonement is made, where death is rolled back, where resurrection happens, where complete healing from sin takes place. It is Bethabara, $B\eta\theta\alpha\nu\iota\alpha$, 81, the place of

beginning (1) and new beginning (8). It is 18 miles, or 31,680 yards from the city of Adam. The Lord Jesus Christ has a Gematria value of 3168. He is the means of atonement between God and men.

This sacred spot is identified by another magnificent symbol – a symbol of the death and resurrection of Jesus as has been memorialized in the Great Pyramid of Egypt.

More will be said about this ancient monument in a subsequent chapter, however it is fitting that this one sublime feature be included here, in the discussion of the *"house of crossing over."*

The Great Pyramid, aside from all the other pyramids of Egypt, is indeed one of the wonders of the ancient world, not only in its construction, but particularly in its symbolism. Succinctly stated, this magnificent structure stands at the head of the Nile Delta as a monument to the great Plan of God for the salvation of men through the atonement offering of the Lord Jesus Christ. His birth, baptism and death are its central feature, being pictured at the juncture of the First Ascending Passage, the Horizontal Passage, and the Grand Gallery. It is at this juncture that an angle is formed with gravity that is 26° 18' 9.7". It has been appropriately named "The Christ Triangle." The hypotenuse of this famous triangle tells the 33 1/2 years of Jesus' ministry; and the juncture of its base and verticle sides tell the date of his baptism at 30 years of age. It can be shown graphically as follows:

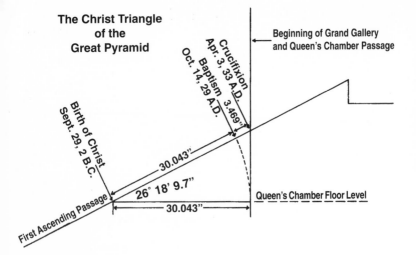

The Christ Triangle
of the
Great Pyramid

Beginning of Grand Gallery
and Queen's Chamber Passage

Crucifixion
Apr. 3, 33 A.D.
Baptism 3.469"
Oct. 14, 29 A.D.

Birth of Christ
Sept. 29, 2 B.C.

30.043"

26° 18' 9.7"

First Ascending Passage

30.043"

Queen's Chamber Floor Level

This central feature of the Great Pyramid is also the "central feature" of the entire Plan of God for the redemption and restoration of man. The Great Pyramid, in fact, is a monument to this great Plan. It is positioned at the head of the Nile Delta as a "gateway" to the abundant life pictured by the Delta, the most fertile land on the face of our planet. That largest delta on earth, is a very fitting picture of the seven-featured Feast of Tabernacles – earth's Great Millennium.

Project this angle outward, its base resting on its latitude of 30° and its hypotenuse will pass directly through the town of Bethlehem. However, if we project the hypotenuse still further, amazingly it will pass through the Jordan river at Bethabara, the *house of crossing over* – the place where atonement, resurrection, and reconciliation to God are clearly pictured.

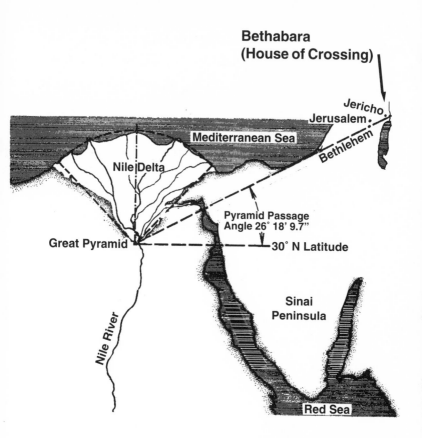

Yet the river still flows south, slowly now, as it levels out, pacing its final four miles to its resting place, where it disappears into the sluggish salt-laden waters of the Dead Sea. Just four more miles until it is interred into the great reservoir of death. Yet, it is four miles of hope, measured as 21,120 feet. That hope for the Jordan river (Adamic Death) lies in the promise given to Isaiah that *"A virgin shall conceive and bear a son and shall call his name Emmanuel."* It has a Gematria value of 2112.

Just as Lazarus, who had been dead four days, was given the command *"Lazarus, come forth,"* so the river carries its sentence of death four more miles, to await the healing of the great reservoir of death.

Such then, is the river Jordan, without any parallel – historical or physical – in the entire world. A river whose entire course is below the level of the sea. Three times were its waters parted by the direct agency of God, that His servants might pass over. It is a river that has never been navigable, disappearing into a sea which has no outlet. Indeed the Psalmist called it *"The River of God"* (Psalm 65:9)

Mt. Hermon

Lake Huleh

Sea of Galilee

Dead Sea

6

The Dead Sea

The surface of the Dead Sea is the lowest spot on the face of our planet. Until recent years its surface has been about 1,300 feet below the level of the Mediterranean. The evaporation rate on its surface has generally equaled the flow of the Jordan which empties into it, leaving behind a dense residue of salt and other minerals. Its water has five to eight times the saline content of the world's oceans. Fish, leaving the Jordan delta waters, die within minutes after swimming into the Dead Sea. The underground regions beneath the sea rumble with volcanic activity, bubbling up hot springs of asphalt.

This sea of death is at the lowest spot in the Great Rift Valley, sluggishly collecting the waters of the Jordan, and interring them into its reservoir of death. It very aptly pictures earth's great reser-

voir of death – all who have died because of the sin of Adam.

Recent events have, however, changed this balance of the river and the Dead Sea. The Jordan River and all of its tributaries have either been dammed or diverted for the purposes of irrigation, leaving only a small amount to be swallowed by the Dead Sea. As a result, the Dead Sea is dying. Yes, the sea which represents the great reservoir of death, is actually dying.

Since 1970, this saline sea has been dropping at the alarming rate of 3.3 feet per year. It has not only been a perplexing reality for those who make their livelihood along its banks, but an alarming one for the ecosystem of the entire area.

At the town of Ein Gedi, a spa was built in 1986, offering visitors mud wraps and therapeutic swims. Customers only needed to walk a few feet from the main building to reach the shore, and take their salty dip in the Dead Sea. Today, the shore is more than three quarters of a mile away from the spa, and visitors must be transported there in wagons.

In recent years, a proposal has been made to channel water from the Gulf of Aqaba through power-producing generators, having it flow down into the Dead Sea. The plan, called the Red-Sea-Dead-Sea Canal, sounds workable, however there are two big problems – money and salt water. The proposed 120-mile canal, carrying salt water from the Red Sea would upset the saline balance which has existed

in the Dead Sea for untold Millennia. The sea needs an inflow of fresh water, not salt water.

The appellative "Dead Sea" is not a Biblical name. In Scripture it is sometimes called the *"Salt Sea,"* and often *"Sea of the Arabah."* However, "Dead Sea" is a very appropriate moniker, for it does indeed represent the great reservoir of death into which all mankind have been falling since the sin of Adam. The Hebrew text of the Old Testament uses the word *"Sheol"* to describe this condition. That they are one and the same place, or condition, we have the amazing confirmation by the Gematria of both names.

The Sea of the Arabah

הים הערבה

337

Sheol

שׂאול

337

The other Biblical name – *Salt Sea* – bears a similar relationship in its Gematria. This time it produces a mirror opposite, which is common in the use of Gematria.

Salt Sea

ים המלח

133

Sheol

שאל

331

Both spellings for Sheol (שאל and שאול) are used in the Masoretic Text.

This sea of death is the lowest spot in the 3,700-mile[1] long Great Rift Valley, which extends from the Taurus Mountains in Turkey to the Zambezi Valley in Africa. Through the southern portion of this valley (western branch) flows

1 From http://en.wikipedia.org/wiki/Dead_Sea

the Nile River northward, bringing life to the barren desert of northern Africa. Through the northern portion of this great gash in the earth's surface, flows the Jordan River southward, ending in the sea of death. Both rivers speak loudly of the necessity and provision for the redemption of the human race.[1]

The Jordan River flows directly south – a direction which, in the symbology of the Bible, represents going away from God. It pictures Adamic Death. The Nile River flows directly north, toward God, and its life-giving water pictures the restoration of life through Jesus Christ.

It is no mere accident of nature that this valley is 3,700 miles from north to south, containing the lowest place on the surface of the earth. It appears to be part of a magnificent plan by the Creator illustrating man's descent into death and his restoration out of it. The mere mention of the number 37 suggests it is part of that plan, for, as we have shown, the numbers 3 and 7 are basic to creation.

370 = Foundation of the earth , ארץ יסדה, (Isaiah 48:13)
370 = He hath founded the earth, ארץ יסדה, (Amos 9:6)
37 = Truth, לוא

This is but a small sampling of the more than three

1 The southern portion of the Great Rift Valley, containing the Nile River, is the subject of the book *NILE: the Promise Written in Sand,* by Bonnie Gaunt, available from Adventures Unlimited Press, auphq@frontiernet.net.

hundred uses of the number 37 and its multiples in the Old and New Testaments, telling of creation, salvation and restoration, and the means by which this great work has been accomplished – the Lord Jesus Christ.

The mirror opposite of 37 – 73 – also plays a prominent role in the story of Creation. In Proverbs 3:19 we find the words: *"The Lord by wisdom hath founded the earth; by understanding he established the heavens."* Here the word *"wisdom"* in the Hebrew text is חכמה which has a Gematria value of 73 and a place value of 37. From this we could deduce that *"wisdom"* is the means-by-which He made the earth and all that is in it, including man. This use of the 3 and 7 is magnificently displayed in Genesis 1:1, the first verse of the Bible. Here we have *"In the beginning God created the heaven and the earth,"* whose Gematria value is 37 x 73. The sum of the numbers from 1 to 73 will become 37 x 73.

1 + 2 + 3 + 4 + 5 + 6 + 7 72 + 73 = 37 x 73

In the beginning God created
the heaven and the earth = 37 x 73

After finding the number 3,700 in the length of the Great Rift Valley, it was a joyful discovery to find that the elevation in the extremes of this awesome valley were 7,300 feet.

The highest point in this valley, which is in south Kenya is 6,000 feet above sea level, and its lowest point is the Dead Sea, which had an elevation of 1,300 feet below sea level, before Israel and Jordan began tapping the Jordan for irrigation.

6,000 feet above sea level (Great Rift Valley in Kenya)

1,300 feet below sea level (Dead Sea)

7,300 Total elevation of Great Rift Valley

The numbers strongly suggest the possibility of Divine Design in its creation. It appears that the Divine Purpose of this great gash in our earth is for the illustrating of God's grand and awesome plan for the salvation of man, through His agent, the Lord Jesus Christ. It could be termed an "Earth Parable."

In September 2005 a new fissure **37 miles** in length has opened in the Afar Desert in northeastern Africa. Scientists are calling it "The birth of a new ocean basin." Professor Dereje of the Addis Ababa University said the fissure is the beginning of a long process, which will eventually lead to Ethiopia's eastern part tearing off from the rest of Africa, allowing a sea to form in its gap. (http://www.cbsnews.com/stories/2005/12/10/tech/main1115779.shtml)

Do we have any evidence from the Bible that such a parable was built into the construction of this Rift?

Yes! We have a magnificent vision/prophecy in the 47th chapter of the book of Ezekiel. It tells of a time when the Dead Sea will become a "live sea." This prophecy describes a river, flowing from the Temple, beginning as a small stream with ankle-deep water, then further downstream it becomes knee-keep, then yet further it becomes waist-deep, and eventually the waters were deep enough for swimming. This copious stream, in the vision, flowed down into the Dead Sea and healed its saline waters so that an abundance of fish could live in it. But let's read the scripture:

> *"Afterward he brought me again unto the door of the house; and, behold, waters issued out from under the threshold of the house* (temple) *eastward: for the forefront of the house stood toward the east, and the waters came down from under from the right side of the house, at the south side of the altar.*
>
> *Then he brought me out of the gate northward, and led me about the way without unto the utter gate by the way that looketh eastward; and, behold, there ran out waters on the right side.*
>
> *And when the man that had the line in his hand went forth eastward, he measured a thousand cubits, and he brought me through the waters; the waters were to the ankles.*
>
> *Again he measured a thousand, and brought me through; the waters were to the knees. Again he measured a thousand, and brought me*

through; the waters were to the loins.

Afterward he measured a thousand; and it was a river that I could not pass over; for the waters were risen, waters to swim in, a river that could not be passed over." (Ezekiel 47:1-4)

In the vision, Ezekiel saw this mighty river flow down into the Dead Sea, and when it entered the sea it healed the deadly waters and the sea became alive – fish swam in it and thrived. So, Ezekiel continued:

"... and everything shall live whither the river cometh."

Then he goes on to describe the trees that grew on both sides of this river, whose fruit were a perpetual life-giving abundance. These same trees were in the vision that the Apostle John saw – Revelation 22:1-2:

"And he showed me a pure river of water of life, clear as crystal, proceeding out of the throne of God and of the Lamb. In the midst of the street of it, and on either side of the river, was the tree of life, which bare twelve manner of fruits, and yielded her fruit every month: and the leaves of the tree were for the healing of the nations."

These two visions were given more than 600 years apart, yet they describe the same scene, and tell the same story: a life-giving river and trees whose fruit and leaves are for healing.

In Ezekiel's vision the waters came from the Temple of

God, and in John's vision the waters came from the Throne of God. The source is the same, just different descriptions of the same concept.

And remember where the pure waters of the Jordan river came from? It was from snow-capped Mount Hermon. The connection is magnificent!

We saw that Mount Hermon is at 33.3° N. Latitude, and at 33.3° E. Longitude (by the old method when the prime meridian went through Paris). Also we noted that the three springs below Mount Hermon, where the pure cool refreshing waters issued forth, had a total Gematria value of 333.

127 = Hasbani, הסבני
84 = Leddan, לדן
<u>**122 = Banias, בנים**</u>

333

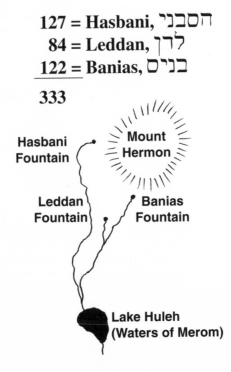

Obviously, the number 333 represents the pure water of life originating from Mt. Hermon, the dwelling of God. Just so, in the two visions, the pure water of life issues forth from the Temple of God and the Throne of God. It began as waters that were "ankle deep." The literal translation from the Hebrew text reads: *"waters that were ankle deep."* It has a Gematria value of 333. It is not just a random coincidence; it is a planned and intentional illustration of the pure life-giving waters coming down to man from the heart of God.

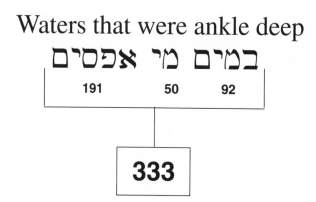

Waters that were ankle deep

As Ezekiel described the river he saw in vision, he saw that it had given life to everything where it flowed, and so he wrote: *"... so will live, everything where the river flows."* Ezekiel was probably unaware that he was also giving a numerical clue to the identity of *"everything."* The Gematria is magnificent.

Everything where the river flows

כל אשר יבוא שמה הנחל

| 93 | 345 | 19 | 501 | 50 |

1008

That *"everything"* is the earth and all that is on it. This beautiful number – 1008 – describes our entire earth, including our satellite, the moon. And this number also describes the One who will bring life. The combined diameters of our earth and moon is the magnificent number 10080.

Moon

10,080 Miles

Earth

When the angel told Mary, at the time of the conception of Jesus, *"He shall be great, and shall be called the Son of the Highest, and the Lord God shall give Him the Throne of David"* (Luke 1:32), he was also giving a clue to the identity and work of this marvelous child who would be born. He would be the one through whom *"All the families of the earth"* would be blessed, as God had promised to Abraham. And this blessing would come when he received his great power to rule on David's throne during earth's great Millennium.

10080 = He shall be great, and shall be called the Son of the Highest, and the Lord God shall give him the throne of David.

This very special child that was to be born of Mary is the one the prophet Isaiah had written about. He said:

> *"Unto us a child is born, unto us a son is given: and the government shall be upon his shoulder: and his name shall be called Wonderful, Counsellor, the mighty God, the everlasting Father, the Prince of Peace. Of the increase of his government and peace there shall be no end, upon the throne of David, and upon his kingdom, to*

order it, and to establish it with judgment and with justice from henceforth even for ever." (Isaiah 9:6-7)

This is why *"everything where the river flows"* has a Gematria value of 1008; it is prophetic of the complete global transformation from man's governments of selfishness and death, into the beauty of Divine Government, bringing peace, goodness and life.

Ezekiel went on to describe this river of life that flows down from the Temple to the Dead Sea. He said, *"The water there becomes fresh."* It is a transfomation from a death condition to a life condition. This promise has a Gematria value of 432. *"World"* in the Hebrew text of the Old Testament has a Gematria value of 432. Just as we have seen with the number 1008, it describes a complete global condition – our world, our earth.

432 = The water there becomes fresh
432 = World, תבל

It is through the birth and death of the Lord Jesus Christ that this transformation can, and will, engulf our earth. He was born in Bethlehem, and was crucified in Jerusalem. The story of his human life and ministry, could be called "From

Bethlehem to Jerusalem," for that is the reality of its history. Two cities that are a mere six miles apart. But their Gematria is positively amazing. When we multiply the letter-numbers in both names, we get the number 432 for each of them (zeros dropped).

Bethlehem

$B \eta \theta \lambda \varepsilon \varepsilon \mu$

2 x 8 x 9 x 30 x 5 x 5 x 40

432

Jerusalem

ירושלם

40 x 30 x 300 x 6 x 200 x 10

432

Saviour

מושיעו

6 70 10 300 6 40

432

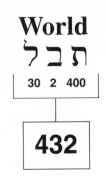

World

תבל

| 30 | 2 | 400 |

432

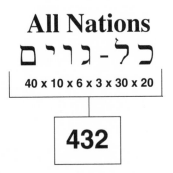

All Nations

כל - גוים

| 40 x 10 x 6 x 3 x 30 x 20 |

432

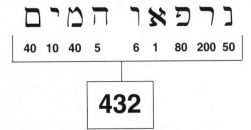

the water there becomes fresh

נרפאו המים

| 40 | 10 | 40 | 5 | 6 | 1 | 80 | 200 | 50 |

432

From Bethlehem to Jerusalem became the human experience of the Lord Jesus Christ for 33 1/2 years. During

that time he was the living *"Last Adam,"* for he came to take Adam's place in death, that all who had lost life through Adam's disobedience, may have it again in its full abundance – all that Adam lost. Just as "dominion" had been given to the first Adam, so "dominion" has been given to the last Adam. He came to be the King on David's throne, and to establish Divine Government in the earth. It will indeed be a "One World Goverment" but not the kind that selfish man is now attempting to foist upon the world.

How amazing it is to realize that there are just six miles between Bethlehem and Jerusalem. Six is the number of man and also the earth-number. Jesus' earthly experiences led him from Bethlehem to Jerusalem. But the distance comes alive with meaning when we realize that six miles is 31,680 feet – and the name Lord Jesus Christ has a Gematria value of 3168.

In reality, if water were to flow from the Temple down into the Dead Sea, as Ezekiel saw in his vision, it would flow through the Wadi al Junan, which carries the overflow from spring rains down to the sea. This natural watercourse between Jerusalem and the Dead Sea enters the sea at 31.68° N. latitude – the same exact latitude as the place of Jesus' birth in Bethlehem. It beautifully illustrates the fact that the Lord Jesus Christ is the means by which the prophetic "sea" is healed, and its occupants will again have life.

In fact, the entire watercourse, from the Temple to the Sea is, if we drew a straight line between them, 15 miles,

which is 79,200 feet. (In reality the actual flow is much further because of the twists and turns of the natural terrain from the mountains of Jerusalem to the below sea level elevation of the Dead Sea.) This straight-line distance of 79,200 feet also is descriptive of the means of the healing of the sea, for the name Lord Jesus Christ, if spelled in Hebrew, has a Gematria value of 792.

In the vision which Ezekiel saw, the Dead Sea became a living sea. Would this also include the possibility that the Dead Sea will actually become a living sea? After all, when all those who died "in Adam" are made alive "in Christ," why have something remaining in the earth which still pictures the great reservoir of death? Will that sea of death actually be brought to life?

Speculating into the future is risky. However, if it were indeed brought back to life, it would change from representing death to representing the resurrection. And, would the stream Ezekiel saw be enough of an inflow of fresh water to heal the huge Dead Sea? After all, the Jordan – a much larger flow of water – has been emptying into the Dead Sea for untold millennia, and the sea remained salty.

We spoke earlier of the "Red Sea-Dead Sea Canal" that is being proposed by the Israeli and Jordanian goverments. To date, their most recent expectations are to develop a huge de-salinization plant, which would convert the water from the Red Sea into fresh water before emptying it into the Dead Sea. However, one huge problem still remains: there is no

outlet from the Dead Sea – it keeps all the water it receives, and maintains its existence through evaporation, which in turn, leaves the salt and other minerals behind. To really be a living sea, this huge body of water needs an outlet.

Zechariah prophesied concerning the water that will flow from Jerusalem to the Dead Sea, and he described it slightly differently than the vision which Ezekiel saw.

> *"On that day living water will flow out from Jerusalem, half to the eastern sea and half to the western sea, in summer and in winter. The Lord will be king over all the earth. On that day there will be one Lord, and his name the only name."* (Zechariah 14:8-9)

Zechariah saw water flowing both ways from Jerusalem. Clearly the "western" sea would be the Mediterranean; but the "eastern" sea is not so positively defined. Some interpret it to mean the Dead Sea, and others suggest it is the Gulf of Aqaba (Red Sea). The Dead sea is definitely east of Jerusalem – its northern end is at the same latitude as Jerusalem, directly east.

First, it must be recognized that Zechariah is using pictorial language, describing what the prophet Micah had prophesied: *"The law shall go forth from Zion, and the word of the Lord from Jerusalem."* It is describing the going forth of the laws of Divine Government to all the earth, both east and west. Those laws, when kept, will bring life, thus they are pictured as water flowing.

Just as the water of life flowed from Mount Hermon (Sion), so the water of life will flow from Jerusalem (Zion).

Mount Hermon is literally there and its pure fresh water literally flows from the three springs. It is reality as well as being symbolic. Will the waters flowing from Jerusalem be literal as well as symbolic? Only time will fully answer that question. However, for waters to literally flow from Jerusalem both to the east and to the west, will require some changes in the terrain and land levels. These changes would very probably provide an outlet for the waters of the Dead Sea, allowing it to become a live sea.

Whatever the method and process, it does not seem likely that the Dead Sea will remain "dead" when that which it symbolizes has been made alive.

The stream of life-giving water which Ezekiel saw in vision flowed from under the Temple, symbolizing its source to be from God. The natural watercourse from Jerusalem down to the Dead Sea is the Wadi Al Junan, which empties into the sea at 31.68° N. latitude. This is about six miles south of the point at which the waters of the Jordan flow into the Dead Sea. Distances here must be calculated using the elevation of the sea prior to the time when Israel and Jordan began tapping the river for irrigation and depleting its natural flow.

A bit of calculation reveals the awesome fact that the distance between the "source" of the Jordan – Banias Fountain – and 31.68° N. latitude is 111 miles, or 888 furlongs.

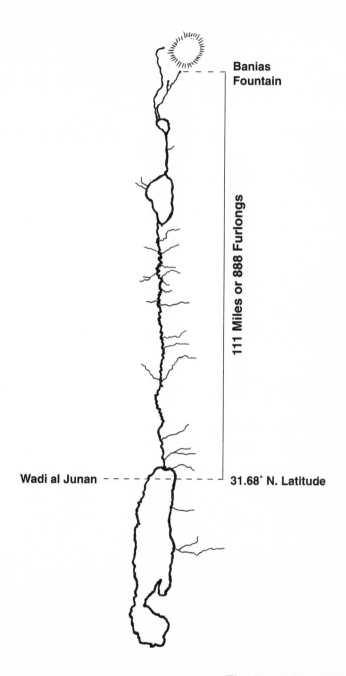

Banias
Fountain

111 Miles or 888 Furlongs

Wadi al Junan - - - - - - - - - - - - - 31.68° N. Latitude

The entire distance, from that which represents the *source* of life to that which represents the *restoration* of life, is 111 miles, or 888 furlongs – the numbers which represent Jesus. He is the life-giver and the life-restorer.

When Isaiah prophesied the birth of Jesus, he said one of the names by which he would be called is Wonderful. It has a Gematria value of 111. And the name Jesus has a value of 888. It was because he shed his righteous blood in the place of the guilty blood of Adam that salvation and restoration can be a reality.

111 = Wonderful, אלפ

111 = The blood of Jesus, το αιμα Ιησου, (I John 1:7)

888 = Jesus, Ιησους

888 = Salvation of our God, ישועת אלהינו,

 (Isaiah 52:10)

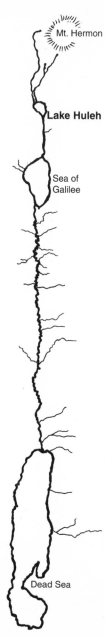

Mt. Hermon

Lake Huleh

Sea of
Galilee

Dead Sea

7

Jericho to Jerusalem

Jericho, the "City of Palms," is said to be the oldest city in the world that is still inhabited. It is situated in the plain of the Jordan at about 800 feet below sea level.

Its tropical climate provided for an abundance of flowers and fruit trees, giving the name יְרוֹחוֹ which means *"breath"* or *"fragrance."* In later times, the spelling of the name was changed to יְרִיחוֹ, meaning *"city of the moon."* These two names are an integral part of the symbolisms which surround this ancient city.

The straight-line distance from Jericho to Jerusalem is 15 miles; however, the precipitous mountain road between the two cities takes the traveler much further. It winds a hazardous path from 800 feet below sea level to 2,500 feet above sea level – an elevation of 3,300 feet. It was, at one

time, a dangerous road to travel, frought with rugged terrain and the fear of marauding bandits.

Jericho is the "key" to Israel. It is the entrance into Israel from the east. It acquired this epithet through much use of the old road which followed the wadis on both sides of the Jordan, crossing the river at the *House of Crossing* – Bethabara.

This is where Joshua brought the Israelites into the promised land after their 40-year experience in the deserts of Sinai and Arabia. But to enter the land they first must conquer Jericho.

It was a city surrounded by walls which would normally provide adequate protection from any type of warfare in that day. But God had a plan for the complete destruction of Jericho. That may sound like a contradiction in the face of its being the world's oldest city still inhabited. Did God's plan for Jericho fail? Let's take a look!

God gave detailed instructions to Joshua for the overthrow and destruction of Jericho.

> *"See, I have given into thine hand Jericho, and the king thereof, and the mighty men of valour. And ye shall compass the city, all ye men of war, and go round about the city once. Thus shalt thou do six days. And seven priests shall bear before the ark seven trumpets of ram's horns; and the seventh day ye shall compass the city seven times, and the priests shall blow with the trumpets. And it shall come to pass, that when they make a long*

*blast with the ram's horn, and when ye hear the
sound of the trumpet, all the people shall shout
with a great shout; and the wall of the city shall
fall down flat, and the people shall ascend up
every man straight before him."* (Joshua 6:3-5)

So Joshua instructed the people accordingly, and the
armed soldiers marched in procession,with seven priests each
blowing trumpets. For each of six days they thus marched
around Jericho once. I'm sure the armed men of Israel won-
dered "what kind of warfare is this?"

Perhaps Joshua, himself, wondered at the military
strategy, but he had the integrity to take God at His word,
and obey.

*"And it came to pass on the seventh day, that
they arose early about the dawning of the day,
and encompassed the city after the same
manner seven times ... and it came to pass at the
seventh time, when the priests blew with the trum-
pets, Joshua said unto the people, Shout ... so
the people shouted when the priests blew with
the trumpets ... the wall fell down flat, so that
the people went up into the city, every man
straight before him, and they took the city."*

Why, after all the wanderings in the desert, looking
forward to the entrance into the land that had been promised
to them, did God instruct Joshua to cross the Jordan at the
chosen ford of Bethabara, and to conquer Jericho in this
strange manner?

Bethabara – the *House of Crossing* over – would be the place where atonement is symbolized. And Jericho would be a type, or illustration, of man's governments. It is not until atonement is fully made that Jesus comes as King on David's throne, conquering man's governments, and setting up his own Divine Government.

It is fitting that the oldest city in the world, still inhabited, should be a picture of man's governments. Dominion was given to Adam in the Garden of Eden. For six thousand years man has been in dominion in the earth, by the authority of God. But it will not always be so. Jericho (man's governments) will be destroyed, never to be rebuilt to all the ages of eternity. Joshua said:

> *"Cursed be the man before the Lord, that riseth up and buildeth this city Jericho."* (Joshua 6:26)

The seven days of marching around Jericho are the same, in symbol, as the seven days of the Feast of Tabernacles. We have seen that the Tabernacles Age is earth's Great Millennium, during which man's governments will be overthrown and Divine Government will be set up in all the earth. It was a seven-day festival.

Scriptures prophetic of this change of the rulership of earth suggest that man's rulership will be conquered early in the Millennial day. But the complete overthrow will of necessity require the eradication of every effect of man's unjust rulership from the hearts of men. We found that the

effects of man's rulership have been:

Oppression

Exploitation

Slavery

Murder

Robbery

Death

To erase these from the hearts of men will be the work of the Millennium. However, by the end of this great Millennium of restoring to man all that Adam had lost, it is prophesied:

> *"I will give them an undivided heart and put a new spirit in them; I will remove from them their heart of stone and give them a heart of flesh. Then they will follow my decrees and be careful to keep my laws. They will be my people, and I will be their God."* (Ezekiel 11:19)

So it happened, when Joshua and the Israelites marched around Jericho seven days, that on the seventh day, they blew the trumpets and shouted, and the walls of the city fell down flat. The Gematria of this event is magnificent. It tells us the whole span of time from the giving of dominion to Adam until the complete removal of the effects of man's rulership from the hearts of men. It is a span of 7,033 years. First, let's take a look at this amazing Gematria, and then see this great span of time briefly and concisely charted.

7033 = "and the priests shall blow with the trumpets,
(7032) and it shall be when they blow long on the
ram's horn, shall shout all the people with a
great shout, and shall fall the wall of the city
down flat."

At the completion of 7,033 years from the creation of
Adam, the "walls of Jericho" will have been felled. Jesus,
earth's divinely appointed ruler, will have put down and
demolished even the last vestiges of the effects of man's
mis-rule of the earth. It will be at the end of earth's Great
Millennium, and the beginning of God's great Eighth Day –
a New Beginning for His beloved human family.

How appropriate that the trumpets blown by the priests
when they conquered Jericho were ram's horns, *yobel,*
Jubilee trumpets. It will be the grand antitype of Israel's
Jubilee – God's grand Jubilee, when all that was lost through
Adam's disobedience will have been restored to man.

The Gematria is amazing. Man will have received com-
plete salvation through the Lord Jesus Christ. The result will
be global, covering our entire earth. Look at the amazing
numbers. The Lord Jesus Christ, when spelled in Hebrew,
has a Gematria value of 792. He came to earth (which has a
mean diameter of 7920 miles) to bring salvation. The
Hebrew word for *"salvation"* has a number value of 792.
As the man Jesus, whose number is 888, he paid the price
for the sin of Adam. The number of years for the comple-
tion of this amazing transaction is 7,033 years. This trans-

action, in its fulness, is 792 x 888 = 7033. They are not random numbers. They tell a magnificent story – the story of the salvation and restoration of the human race.

$$792 \times 888 = 7{,}033$$

Let's compute it another way. Start with the 7,033 years from Adam's creation to the end of earth's Great Millennium, and multiply by *pi* (3.14159), making a great circle of time, just like the marching around Jericho was a circle which represented the entire 7,033 years. Divide that circle by earth's mean circumference, and the result is .888.

$$7033 \times 3.14159 \div 24{,}881.392 = .888$$

The math is mind-boggling! It is beautiful and powerful evidence of a Master Plan. This magnificent plan was conceived long before the creation of man – long before the sun, moon and stars were created and set into motion. This is why Jesus was called *"The Lamb slain from the foundation of the world."* (Revelation 13:8)

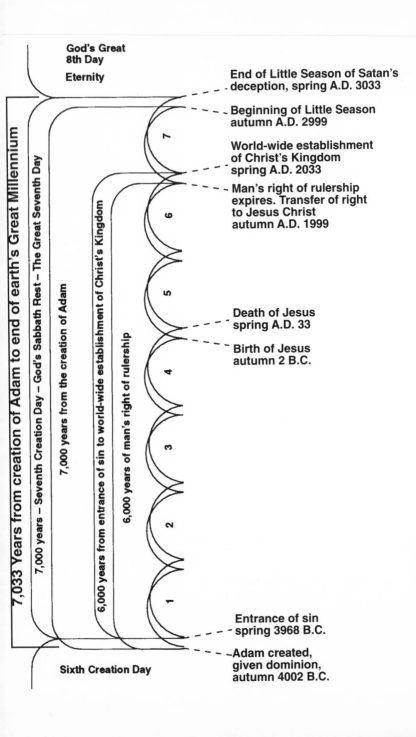

God's Great
8th Day

Eternity

End of Little Season of Satan's
deception, spring A.D. 3033

Beginning of Little Season
autumn A.D. 2999

World-wide establishment
of Christ's Kingdom
spring A.D. 2033

Man's right of rulership
expires. Transfer of right
to Jesus Christ
autumn A.D. 1999

Death of Jesus
spring A.D. 33

Birth of Jesus
autumn 2 B.C.

Entrance of sin
spring 3968 B.C.

Adam created,
given dominion,
autumn 4002 B.C.

Sixth Creation Day

7,033 Years from creation of Adam to end of earth's Great Millennium

7,000 years – Seventh Creation Day – God's Sabbath Rest – The Great Seventh Day

7,000 years from the creation of Adam

6,000 years from entrance of sin to world-wide establishment of Christ's Kingdom

6,000 years of man's right of rulership

The long span of 7,033 years will conclude with the work of earth's Great Millennium finished. The Apostle Paul spoke of this time, and gave us the beautiful assurance that it will indeed be a reality. He said:

> *"Then the end, when he shall have delivered up the kingdom to God, even the Father; when he shall have put down all rule and all authority and power (man's rulership). For he must reign till he hath put all enemies under his feet. The last enemy that shall be destroyed is death....And when all things shall be subdued unto him, then shall the Son also himself be subject unto him that put all things under him, that God may be all in all."* (I Corinthians 15:24-28)

Jericho (man's rulership) will have been completely conquered and destroyed. This was pictured by the walls of Jericho falling down flat, and the Israelite army going in and completely destroying the city. For Jericho, which had begun as a beautiful *"fragrance,"* became a stench because of the effects of sin. Its name was changed to *"city of the moon."*

This ancient city is in the Great Rift Valley – it is part of the effects of sin which caused a rift between God and his human family. Jerusalem is not in the Rift Valley, but is high above. The terrain between the two cities is rugged and steep. If we were to draw a straight line from Jericho to Jerusalem on a map, we would find the distance between the two cities is 15 miles. The difference in elevation is 3,300 feet. Thus

the hypotenuse between Jericho and Jerusalem (still dealing with straight lines) would be 15.013 miles. Of course, if traversing the road it would be even further. But let's look at this basic geometry. Obviously the relationship between these two cities is part of the great plan.

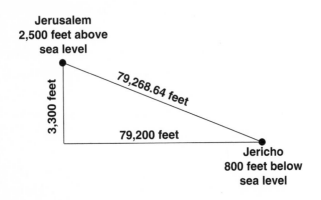

The ascent from Jericho (man's governments) to Jerusalem (Divine Government) bears the numbers 792 - 6 - 864. The numbers tell the story of the purpose of earth's Great Millennium, which is the ascent from man's governments to Divine Government. The mean diameter of our earth is 7,920 miles, thus the 792 represents the earth. And 792 is the Gematria for *"salvation,"* showing earth to be the place of salvation. The number 6 represents man. But joy upon joy, the number 864 is the Gematria for the name *"Jerusalem."*

Jerusalem

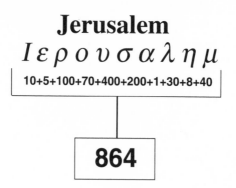

$$I \varepsilon \rho o \upsilon \sigma \alpha \lambda \eta \mu$$

10+5+100+70+400+200+1+30+8+40

864

The means whereby this ascent can be made is Jesus Christ, who, at the age of 33, poured out His innocent blood to pay the price for the sin of Adam.

The 3,300 feet difference between the elevation of Jericho and the elevation of Jerusalem represents the beautiful fact that man can only make this ascent through the blood of Jesus. Man must go up, so to speak, from Jericho to Jerusalem – from man's governments to Divine Government – a difference of 3,300 feet.

330 = Holy and Just One (Jesus), $\alpha \gamma \iota o \nu$ $\kappa \alpha \iota$ $\delta \iota \kappa \alpha \iota o \nu$
330 = to atone, לכפר
330 = Pain, מיר **(through His pain we are healed)**

Jesus obviously knew the meaning and the relationship of Jericho to Jerusalem, because he told a very poignant story about a man who went the other direction – from Jerusalem down to Jericho.

"A certain man went down from Jerusalem to Jericho, and fell among thieves, which stripped

*him of his raiment, and wounded him, and
departed, leaving him half dead. And by chance
there came down a certain priest that way; and
when he saw him, he passed by on the other side.
And likewise a Levite, when he was at the place,
came and looked on him, and passed by on the
other side. But a certain Samaritan, as he jour-
neyed, came where he was: and when he saw
him, he had compassion on him, and went to him,
and bound up his wounds, pouring in oil and
wine, and set him on his own beast, and brought
him to an inn, and took care of him. And on the
morrow when he departed, he took out two pence,
and gave them to the host, and said unto him,
Take care of him; and whatsoever thou spendest
more, when I come again I will repay thee."*

The man who went down to Jericho was Adam. He *"fell
among thieves"* – Satan was the thief who robbed him and
left him for dead. Adam came under the influence of the
thief, Satan, who stripped him of his clothes (his justifica-
tion before God). The sad tale is told in Genesis 3:7-11:

*"And the eyes of both of them were opened and
they knew that they were naked, and they sewed
fig leaves together, and made themselves aprons.
And they heard the voice of the Lord God walk-
ing in the garden in the cool of the day: and Adam
and his wife hid themselves from the presence of
the Lord God amongst the trees of the garden.
And the Lord God called unto Adam, and said*

unto him, Where art thou? And he said, I heard thy voice in the garden, and I was afraid, because I was naked; and I hid myself. And he said, Who told thee that thou wast naked? Hast thou eaten of the tree, whereof I commanded thee that thou shouldest not eat?"

In the parable, the man who went down to Jericho was as good as dead. If help had not come, he would have died.

While the traveler lay there dying, a priest and a Levite came along. As they drew near, and saw the plight of the poor victim lying there covered with mud and blood, they moved to the other side of the road, and hurried past, doing nothing for the injured man. Just so, the sacrifices of the Law, which were in the hands of the priests and Levites, were completely unable to help fallen man or to heal his wounds.

"For the law having a shadow of good things to come, and not the very image of the things, can never with those sacrifices which they offered year by year continually make the comers thereunto perfect. For then would they not have ceased to be offered? Because that the worshippers once purged should have had no more conscience of sins. But in those sacrifices there is a remembrance again made of sins every year. For it is not possible that the blood of bulls and of goats should take away sins." (Hebrews 10:1-4)

But along came the Good Samaritan. He saw the trav-

eler suffering certain death and he had compassion on him. The Good Samaritan is Jesus. He bound up his wounds, poured oil and wine on him to clean off the blood and mud, and to soothe his aching body. It describes the work of redemption, and pictures the work of the spirit (oil and wine) in transforming the sinful nature back into that which can be acceptable to God.

Then the Good Samaritan did something over and beyond the call to help. He put the traveler on his *"own beast,"* which meant that he walked while the injured man rode. They switched places. It is a beautiful illustration of Jesus giving himself for Adam – taking the sinner's place.

The Gematria value for *"own beast"* is 792. Wow! This is amazing! It is the number for "salvation." By telling this story, Jesus was illustrating the fact that he came to earth (7920) to take Adam's place in death, thereby providing salvation (792) to all of Adam's posterity.

The Good Samaritan took the injured man to an inn and paid the innkeeper two pence. A penny was one day's wages, thus two pence would be two day's wages. The allusion appears to be describing the two "days" in which Jesus would be "away," before his return. But the apparent reference to two days is even stronger when we hear him say, *"When I come again, I will repay."* The Good Samaritan revealed here that he plans to return to get the traveler.

The number value of *"I will repay"* is 2000. Perhaps Jesus is suggesting here that his return will be 2,000 years

after his first advent. Perhaps a time prophecy is implied; nevertheless, it is certain that Jesus indicated by this story that he would indeed return for the traveler (Adam).

You cannot return to a place where you have never been. He was talking about coming again to earth.

Jesus said *"when I come again"* I will repay. The Greek words used here may indicate the time of that return. The literal Greek text reads *"in the return."* The words *"in the"* εν τω multiply to 6000 (dropping the rest of the zeros). Was he giving us a time prophecy? Perhaps!

The indication is, from the time-line of chronology, that after 6,000 years of rule by man's governments, *"He whose right it is"* will take his place on David's throne and establish Divine Government in the earth. Is this why Jesus used the words *"in the return?"*

Some interesting Gematria is obtained from the concept of his kingship. Perhaps it is suggesting that after 6,000 years of man's rulership, the promised King would establish his Kingdom of righteousness. The following are examples of the multiplication of Gematria:

6000 = King, *βασιλει*

6000 = Kingdom, *βασιλεια*

6000 = Behold your King, הנה מלכך

Jesus began this parable by saying that the traveler went from Jerusalem down to Jericho. It would seem to follow logically that when the Good Samaritan returned to get the man, he would take him back up to Jerusalem, to his home.

The city of Jerusalem represents the seat of Divine Government. Jericho represents man's governments. Thus the traveler (Adam) will be returned to all that he had before he fell into the hands of the thief (Satan). And, it follows, that all of Adam's posterity – the human family – will be restored with him. The Apostle Paul made this very clear when he said, *"As in Adam all die, so in Christ shall all be made alive."*

This unique city – Jericho – was the scene of a most interesting event in the life of Jesus. He and his disciples were passing through Jericho on their way to Jerusalem, where they expected to celebrate the Passover. And so it was that just a few days before his death, as Jesus was passing through Jericho he saw a little man up in a sycamore tree. The man was Zacchaeus. Luke tells the story:

> *"And Jesus entered and passed through Jericho. And, behold, there was a man named Zacchaeus, which was the chief among the publicans, and he was rich. And he sought to see Jesus who he was; and could not for the press, because he was little of stature. And he ran before, and climbed up into a sycamore tree to see him: for he was to pass that way. And when Jesus came to the place, he looked up, and saw him, and said unto him,*

Zacchaeus, make haste, and come down; for today I must abide at thy house. And he made haste, and came down, and received him joyfully. And when they saw it, they all murmured, saying, That he was gone to be guest with a man that is a sinner. And Zacchaeus stood, and said unto the Lord; Behold, Lord, the half of my goods I give to the poor; and if I have taken anything from any man by false accusation, I restore him fourfold.. And Jesus said unto him, This day is salvation come to this house, forsomuch as he also is a son of Abraham. For the Son of Man is come to seek and to save that which was lost."
(Luke 19:1-10)

Why was this story included in Luke's gospel? And who was Zacchaeus?

This man of small stature was a descendant of Abraham but he held the job of tax collector for the Roman government. Those living in the land of Israel at that time hated the tax collectors, because they were noted for exacting more tax than was legal, and keeping the extra for themselves. And very probably the people of Jericho suspected that Zacchaeus had done a lot of this "over-taxing" – how else would he have become so rich!

But, unlike some tax collectors, Zacchaeus was an honest man. His riches had not come from exacting excess taxes. In fact, he was a very generous man, spending his own wealth to help the poor and needy.

Because this event happened in the city of Jericho, when

Jesus was on his way to Jerusalem, I became curious. Was there more to this story than simply the bad reputation of an honest man?

So I checked the Gematria of the Greek text, and was amazed at what it revealed. My first surprise was the name "Zacchaeus." It means *"pure, innocent, clean."* It is a Hebrew name; and when spelled in Hebrew has a Gematria value of 37.

For those who study Gematria, just the appearance of the number 37 sends tingles up the back of the neck. It is the most amazing number in the entire system of Biblical Gematria, and relates to Creation and the One who brought all things into existence.

This, combined with the awareness of its Gematria in the Greek text, is beautiful indeed.

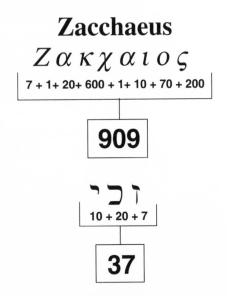

Zacchaeus

$Z \alpha \kappa \chi \alpha \iota o \varsigma$

7 + 1+ 20+ 600 + 1+ 10 + 70 + 200

909

10 + 20 + 7

37

The number nine has the meaning of "wholeness and completeness."

Why do these two magnificent numbers define the name of Zacchaeus? Let's look again at the story.

Jesus announced to Zacchaeus that he would abide in his house. If Zacchaeus is somehow an illustration of Jesus, then Zacchaeus' house would represent the *"house of Israel,"* which at that time was the Jewish nation into which Jesus was born and executed his ministry. Jesus came to be the King of that *"house of Israel,"* and this is pictured by Zacchaeus being up in a tree. For a tree is a symbol of rulership.

Jesus went on to explain: *"This day is salvation come to this house, forasmuch as he also is a son of Abraham. For the Son of Man is come to seek and to save that which was lost."* In pictorial language, Jesus was saying that he had come to the *"house of Israel"* to bring them salvation, because they had become *"lost"* not only through Adam, but also through their inability to keep the Divine Law that had been given to them. But he knew full well that even when he came to his own house, his own would *"receive him not."* The awareness of this rejection was uppermost on his mind, for he knew that when he went up to Jerusalem he would be arrested and put to death, by those of his "household."

Thus it is apparent why Jesus used Zacchaeus to represent himself. But why did he choose Jericho in which to

give this illustration and to tell this story?

Remember, the city of Jericho, even though pronounced the same, had undergone a name-change – it was spelled differently than before. Jericho now meant *"city of the moon."* It pertained to Jesus' death. And even as he spoke, Jesus was aware that in a few days he would be the antitypical Passover Lamb and would die upon a cross on the hill of Calvary – sometimes called Golgotha – at the full of the moon.

And so, Luke begins his historical record of this last trip of Jesus through Jericho by saying, *"And behold a man named Zacchaeus."* It has a Gematria value of 3010. The number 301 identifies that memorable Passover in which Jesus became the antitypical Lamb and fulfilled the type which had been given to Moses the night in which the Israelites left Egyptian bondage.

Jesus knew that he would be the Lamb. And the historical record tells us that he died, hanging on the cross, at 3:01 in the afternoon of Passover, when the priests were killing the Passover lambs. It was the night of full moon. But the moon went into eclipse at the exact time he died. When it rose over Jerusalem that night, it was still in eclipse, for 17 minutes – visible to all. The number 17 is the Gematria value for *"victory."* Yes, his death provided victory over not only Adamic death, but also the additional condemnation because of the nation of Israel having broken their Law Covenant.

The moon, whose light is the reflected light of the sun, was an illustration of that Law Covenant. But at the exact time when Jesus died, the moon eclipsed – the shadow of earth obscured its reflection from the sun – and as the moon came out of eclipse, it now represented a New Covenant. This New Covenant provided a new way to obtain life.

The amazing Gematria which connects all this is most beautiful to behold.

3010 = And behold a man named Zacchaeus
301 = Calvary, κρανιον
301 = Moon, σεληνη
301 = Lambs, אמריך
301 = Pardon, שא (to bear the sin of another)

Jesus was on his way to Jerusalem when he stopped at the house of Zacchaeus. The moon was waxing larger every night, and he knew, when it reached its maximum fulness, he would die upon the cross, as the antitypical Passover Lamb. Yes, the old Law Covenant would be eclipsed that night, and a new way to obtain life provided – a New Covenant.

It is fitting, then, that the hill named Calvary, which means "place of the skull" should also have another name. That name was Golgotha, which has a Gematria value of 186. Amazingly, the value of the name Golgotha is the Golden Proportion of the value for Calvary. The naming of

the hill was not a random choice. It was part of the magnificent plan, for it relates to our earth and moon.

The moon had a vital role to play in the events of the day that Jesus died. The fact that it eclipsed precisely at the moment of his death is no mere coincidence. The display of this Golden Proportion is in the exact relationship of our earth to its moon. The combined radii of the earth and moon is 3,960 + 1,080 = 5,040, forming a Golden Proportion as illustrated below.

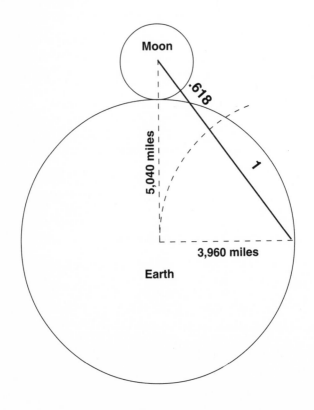

Now let's overlay this illustration with the Gematria values for Calvary (301) and Golgotha (186). Amazingly it produces the Gematria value for the name Jesus Christ. It is no random coincidence: it is planned precision – a precision that formed the very dimensions of our earth and moon. The earth is the "place of salvation," and the moon, providing the reflected light of the sun, is the means through which that salvation is accomplished.

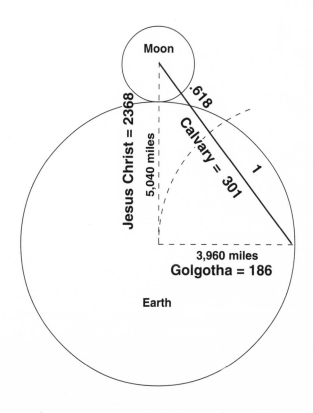

And so it came to be that while Jesus was in the *"house of Zacchaeus"* (the nation of Israel), in the city of Jericho (city of the moon), he chose to speak a parable about his going away and coming again. This parable was given to his closest followers who were with him on his trip to Jerusalem. As they gathered together, probably seated on the floor, Jesus began:

> *"A certain nobleman went into a far country to receive for himself a kingdom, and to return."*

Who is the *"certain nobleman?"* It is obvious from the remainder of the parable that Jesus spoke of himself. However, this identification was not left to our conjecture. It is confirmed by the Gematria which has been encoded into the text.

3168 = "A certain nobleman went"

3168 = Lord Jesus Christ

Note his purpose for going into the far country: to receive a kingdom and then to return – in that order. As he continues the parable, he puts the receiving of the kingdom past tense, then speaks of his return.

> *"... and when he was returned, **having received the kingdom,** then he commanded these servants to be called unto him."*

His official "right of rulership" as King on David's throne precedes his coming for his servants – the ones to whom he gave the commission *"Occupy till I come."*

Look again at the timeline shown on page 140. The 6,000 years of man's right of rulership is shown to expire on Rosh Hoshanah 1999. It appears that the date also marks the transfer of that right of rulership to Jesus Christ, the antitypical King David. This would suggest that he received the kingdom 2,000 years from his birth. Mary had been told by the angel:

> *"He shall be great, and shall be called the Son of the Highest, and the Lord God shall give him the throne of David."* (Luke 1:32)

How marvelous to realize that the Gematria value of that promise to Mary is 10080. It is all inclusive of both the earth and its moon.

10,080
Miles

Moon

Earth

Appropriately, Jesus gave this parable in the city of Jericho – the city of the moon, representing man's 6,000-year rulership – while on his way to Jerusalem, the city representing Divine Government from which he will rule as the antitypical King David. His ascent from Jericho to Jerusalem is represented by the 15 miles (79,200 feet) between the two cities. This rulership is for the blessing of all the earth (7,920 miles diameter), by bringing to mankind the full benefits of salvation (792).

A brief look at the map reveals the relationship between Jericho, Jerusalem and the place where the Wadi Al Junan flows into the Dead Sea. There are 15 miles between each of them.

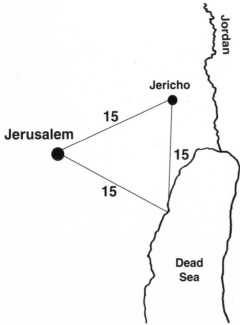

The total distance between the three locations is 45 miles. It is not just a coincidence that the Gematria value for the name *"Adam"* in Hebrew, is 45. The word *"man"* in Hebrew is the same. Since all mankind received their birth through Adam, it is appropriate that they all bear his name. The entire race of man was brought down into death by the disobedience of Adam. But the Apostle Paul assured us that the entire race of man will be brought back out of death through Jesus Christ.

> *"As in Adam all die, so in Christ shall all be made alive."* (I Corinthians 15:22)

The 45 miles between these three locations brings us full circle, from the dominion first given to Adam in the Garden of Eden to the full benefits of Divine Government, represented by Jerusalem, to the full resurrection and restoration of man, as represented by the life-giving water flowing into the Dead Sea, and back to Jericho, for the complete eradication of the effects of man's governments from the hearts of all mankind. It takes us on a journey of 7,033 years and brings us to the threshold of God's Great Eighth Day – the New Beginning – eternity.

It is the geographical illustration of the magnificent plan for the redemption and restoration of man, which the Apostle Paul so beautifully described to the believers at Colosse:

> *"For by him were all things created, that are in heaven, and that are in earth, visible and invis-*

ible, whether they be thrones, or dominions, or principalities, or powers: all things were created by him and for him. And he is before all things, and by him all things consist.... And, having made peace through the blood of his cross, by him to reconcile all things unto himself; by him, I say, whether they be things in earth, or things in heaven."(Colossians 1:16-20)

The number 45, defining the distances from Jericho to Jerusalem to the Dead Sea and back again to Jericho, is more than an allusion to Adam, who brought mankind down into death. It is more completely an illustration of the *"Last Adam"* who brings the human race back up out of death and gives them life.

The total distance, 45 miles, converts to 2,376 feet. This number is the Gematria value for:

2376 = "The One giving us the victory"
1 Corinthians 15:57

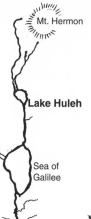

Mt. Hermon and the Great Pyramid

The beautiful snow-covered peak of Mt. Hermon represents the throne, or dwelling place of God. It has often been compared to the topstone of the Great Pyramid in its symbolism – and for good reason.

The Apostle Peter made an allusion to this when he quoted Isaiah, saying, *"Behold I lay in Sion a chief cornerstone."* (I Peter 2:6). In the book if Isaiah, this passage is the word of God to the prophet, thus when putting the two prophecies together, we draw the obvious conclusion that both references are indeed to Jesus Christ, who shares the high position of *"chief cornerstone"* with the Father. And, as mentioned earlier, Peter was obviously using a play on words when he made reference to *"Mt. Sion"* which, in Hebrew means *"peak."* The references to both the Father

and the Son share the same Gematria value – 333 – the numbers relating to Mt. Hermon whose latitude is 33.3°N and longitude is 33.3° E (by using the prime meridian through Paris).

333 = Snow
333 = Thy throne, O God, is forever, (Psalm 45:6)
333 = Behold I lay in Sion a chief cornerstone,
 (I Peter 2:6)
333 = Lord of Lords, *Κυριος των κυριων*

If *"Sion"* here refers to Mt. Hermon, then it presents an interesting observation. Mt. Sion is called the *"chief cornerstone,"* which can be equated with the topstone of the Great Pyramid, or more correctly, what the topstone of the Great Pyramid represents.

 333 = "Behold I lay in Sion a chief cornerstone"
+ 333 = "Lord of Lords"

 666 = "The head of the corner"

This reference to Jesus as being the *"head of the corner"* is from Psalm 118:22, and it suggests the stone will be placed in its lofty position during the great Millennial Day. The text reads:

"The stone which the builders refused is become

the head stone of the corner. This is the Lord's doing; it is marvellous in our eyes. This is the day which the Lord hath made; we will rejoice and be glad in it."

We know this topstone represents Jesus because he quoted this very text and applied it to himself. He called himself *"the stone which the builders rejected."*

The *"day"* when this topstone is lifted into place will be earth's great Millennial Day – a time of rejoicing and gladness. The lifting of this stone into place is the lifting up of Jesus as earth's new King – the long-promised King on David's throne.

The distance between these two great prophetic "peaks," the topstone of the Great Pyramid and the snow-capped peak of Mt. Hermon, is 358 miles (straight-line distance).[1] How magnificent! The Gematria value of the long-promised *"Messiah"* is 358.

358 = Messiah, מָשִׁיחַ

358 = Shiloh comes, יָבֹא שִׁילֹה
(Genesis 49:10)

In view of the previous distances which we have observed with their numeric meaning, I think we can say

1 www.wcrl.ars.usda.gov/cec/java/lat-long.htm

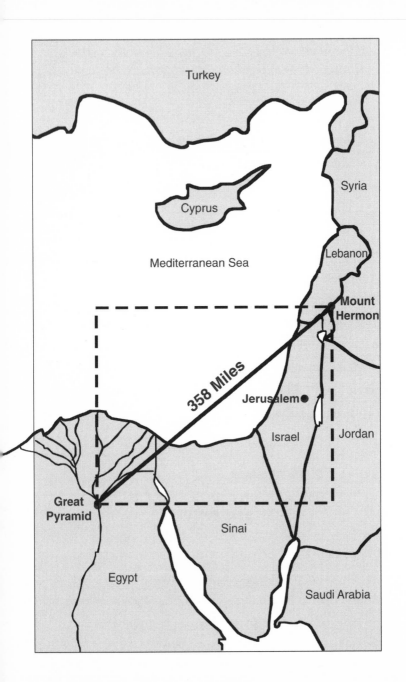

164 Jordan: the Promise Fulfilled

with confidence that this distance of 358 miles between the two peaks which represent the exalted Jesus Christ in his Millennial Glory, is part of the magnificent pattern laid out in the geographical positioning of these symbols.

This pattern is so amazing because it causes us to think in superlatives. I was made aware of this by correspondence with a gentleman who lives in Queensland, Australia. I would like to quote from the pen of James Heyworth as he made reference to the Great Pyramid:

> "... the greatest rift valley on earth that contains the lowest land surface on the planet, the world's longest river, after crossing the world's biggest desert, crosses the world's longest land parallel where it crosses the world's longest land meridian. Which is where the four right angle corners of the four equal quarters of the world's land meet, the centre of all the world's land and the site of the number one wonder of the ancient world and the modern world, if the truth were known, which is built on one of the few places on the surface of the earth that can support its weight; which is also the pivot point of the Nile Delta quadrant (the world's most fertile land) its geometric and geographic centre and I would say the most important position on the whole river."

His list of superlatives are amazing but true. And let me add one more amazing fact to the list. In view of the fantastic positioning of the Great Pyramid on the surface of

our planet it is with continued amazement that we find the height of this ancient stone edifice, from its socket level base to its summit platform, to be 5,449 Pyramid Inches. The average height of the earth's land above sea level is 5449 inches (454 feet).[1]

The Great Pyramid is situated in the geographical center of the land surface of the earth. This means there is more land area in both its meridian and latitude than in any other meridian and latitude on the globe. For this reason it is by far the most suitable position for the zero meridian for all nations, and there is evidence that this was indeed the ancient prime meridian.

Using the Great Pyramid as the prime meridian of the world, we find that the countries east of this meridian are largely populated by non-Christian people, and the coun-

1 www.infinitetechnologies.co.za/articles/thegreatpyramid.html

tries west of this meridian are largely populated by Christian people.

East of the Great Pyramid there are about 1,295 million non-Christian people versus only 122 million Christians. West of the Great Pyramid there are about 940 million Christians versus only 179 million non-Christians. The Great Pyramid divides the Christian and the non-Christian people of the world.

Let's look at this amazing relationship of Mt. Hermon to the Great Pyramid. The straight-line distance is 358 miles, which we have seen is a reference to the Messiah, whose Gematria value is 358. But note the dimensions of a rectangle drawn on that diagonal, they are fantastic!

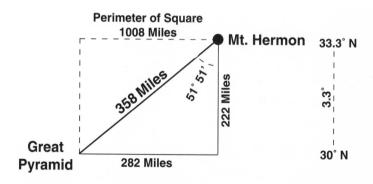

The perimeter of the square would be 1008 miles. The numbers 1 and 8 when used together, speak of the Beginning and the New Beginning, and thus of the Beginner and the New Beginner, Jesus Christ.

The figures 1008 and 10080 play an important role in the Gematria of the Bible as well as in the geometry of our earth and its moon. The combined diameters of earth and moon is 10,080 miles.

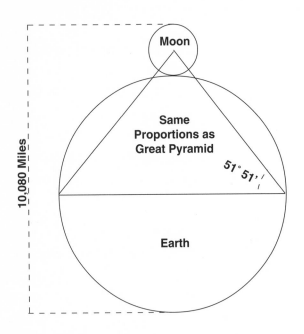

Some may ask, "Why show the earth and moon touching, when in reality they are about 238,866 miles apart?" It is because these two bodies orbit the sun as a unit, therefore we treat them as a unit, combining their diameters to give the total dimension of the two orbs. When we do this, it is observed that the centers of each form the height of a pyramid whose proportions are precisely that of the Great

Pyramid of Giza with a base angle is 51° 51'. That is awesome! However, it is even more awesome when we realize that the diagonal of the rectangle drawn on the distance from Mt. Hermon to the Great Pyramid also has an angle of 51° 51'. Was it pre-planned, or merely a freak coincidence? Take a look!

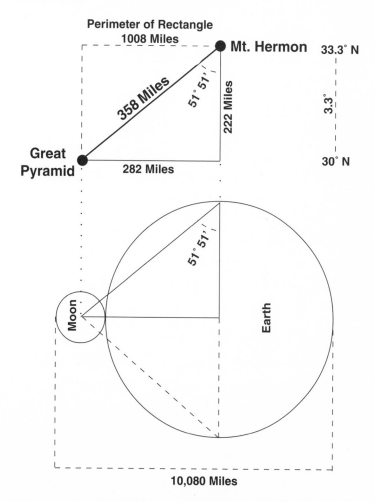

Mt. Hermon and the Great Pyramid 169

The figures we have obtained from these diagrams are:

```
  1008
 10080
   358
   282
   222
```

Below are some of the examples of the Bible's use of these numbers in its system of Gematria. Obviously they are numbers with meaning, and they all have to do with the story of salvation through Jesus Christ and his setting up Divine Government in the earth.

1008 = **The work of thy fingers, (Psalm 8:3)** (Obviously referring to the work of creation.)

1008 = **When the Lord of Hosts shall reign in Mt. Zion, (Isaiah 24:23)** (When Divine Government will be set up in the earth.)

1008 = **The Lord is high above all nations, and His glory above the heavens, (Psalm 113:4)** (Another reference to the time of Divine Government in the earth.)

1008 = **Everything where the river flows, (Ezekiel 47:9)** (The work of resurrection and healing from the effects of sin during the Millennium.)

10080 = He shall be great, and shall be called the Son of the Highest, and the Lord God shall give Him the throne of David, (Luke 1:32)

10080 = And they sing the song of Moses, the servant of God, and the song of the Lamb, (Revelation 15:3)

358 = Messiah, משׁיח

358 = Shiloh comes, (Genesis 49:10)

282 = The breath of life, (Genesis 6:17)

282 = Her seed, (Genesis 3:15) (Prophetic of Jesus)

222 = Name of Christ, (I Peter 4:14)

2220 = Unto you that fear my name shall the Sun of Righteousness arise with healing in His wings, (Malachi 4:2) (A prophecy of the healing work of Jesus Christ during the Millennium.)

2220 = I will put my law in their inward parts, (Jeremiah 31:33) (The laws of Divine Government will be written in the hearts of men during the Millennium.)

The Great Pyramid is situated at the head of the Nile Delta. In fact, the outermost reaches of the Delta form a quadrant of a circle whose center point is the Great Pyramid, with a radius of 108 miles. If we were to complete the circle, it would have a diameter of 216 miles, with the Great Pyramid at its center. It is called the Delta circle.

Project an image of this circle with its circumference resting on the Great Pyramid, and it forms a vesica completely enclosing the Delta. Students of Sacred Geometry have called the vesica the "birth canal of creation." However, here it appears to be the birth canal of *re-creation* – for the Delta is a beautiful picture of the Millennium, when all that was lost through Adamic sin will be restored to mankind through the resurrection and healing of the people.

The Nile Delta is the most fertile land on the face of the earth. There the Nile deposits its rich nutrients, bringing life in abundance.

Great Pyramid

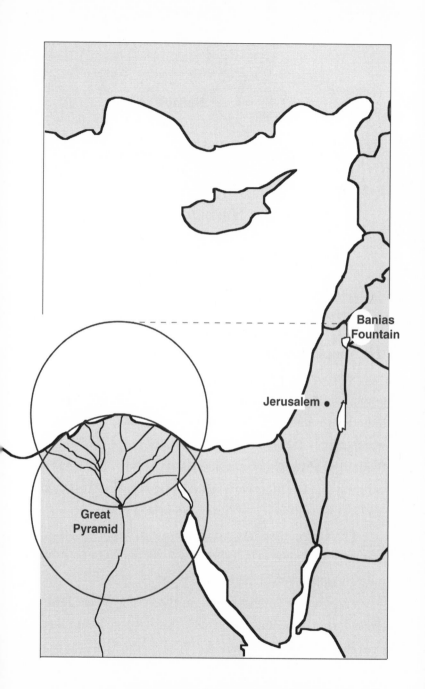

Mt. Hermon and the Great Pyramid 173

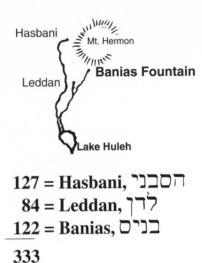

127 = Hasbani, הסבני
84 = Leddan, לדן
122 = Banias, בנים
333

Overlapping the centers of the Delta circles creates the vesica, illustrating the resurrection and re-creation of all that had been lost in Adam – the time of earth's Great Millennium. These overlapping circles reach all the way to the latitude of Banias Fountain. Of the three principal fountains which supply the fresh life-giving water to the Jordan, the Banias has always been considered as the "source." Thus it is fitting that the life-giving waters of Banias be illustrated here as the well-spring of life in the Millennium.

The Delta circle has a diameter of 216 miles. It is an amazing miniature of the moon, whose diameter is 2160 miles. It appears to be part of the plan.

The Great Pyramid stands in the center of the Delta circle, just as in the illustration of earth and moon, its topstone rests in the center of the moon.

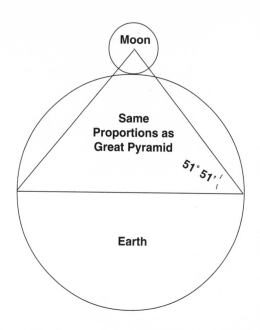

The relationship of the topstone of the Great Pyramid to the moon is apparent. It rests in the precise center of the moon circle, just as it also stands in the precise center of the Delta circle.

A square drawn around the moon circle will have a perimeter of 8,640 miles – a reference to the sun, whose diameter is 864,000 miles.

Perimeter of square 8,640 miles

Mt. Hermon and the Great Pyramid 175

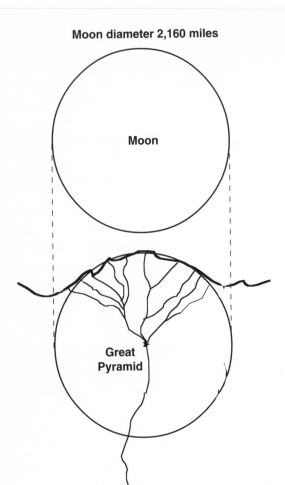

Moon diameter 2,160 miles

Moon

Great
Pyramid

Delta circle diameter 216 miles

Jesus referred to himself as *"the stone which the build-ers rejected,"* (Matthew 21:42; Mark 12.10) , which has a Gematria value of 2160, clearly indicating his connjection to both the Great Pyramid and the moon. The topstone of the Great Pyramid has never been placed. However, King

David prophesied of the time when that topstone will indeed be placed upon its high and lofty peak. He said, *"The stone which the builders rejected has become the headstone of the corner."* He was speaking of the time when Jesus would be the King on David's throne.

And so, it becomes apparent that the moon and the Delta circle relate to the same event – the setting up of Divine Government during earth's Great Millennium. We saw in the previous chapter the relationship of the moon to the Covenant. That Law Covenant given on Mt. Sinai was represented, in symbol, by the light of the moon. At the precise time when Jesus breathed out his last by saying *"It is finished,"* the moon became full and began to go into eclipse. The shadow of earth passed across its surface, and as it passed, the light of the moon began to appear on the other side until the shadow had fully passed.

This heavenly sign indicated the passing away of the Law Covenant and the birth of a New Covenant – both represented by the moon. As the shadow of earth passed across the moon, the appearance of the moon was like a mirror image – first, light was on the right side, then light was on the left side. Thus the numbers for *"Covenant"* and *"Moon"* are mirror opposites, or reflections of each other.

2160 diameter of Moon
216 diameter of Delta circle
612 = Covenant, ברית

$$6 + 1 + 2 + 2 + 1 + 6 = 18$$
$$6 \times 1 \times 2 \times 2 \times 1 \times 6 = 144$$

As the shadow of earth passed across the moon

the Old Covenant was dying

and the New Covenant was being birthed.

"He taketh away the first that he may establish the second."
(Hebrews 10:9)

By his death Jesus not only put to death the old Law Covenant, but he brought to the birth the New Covenant. And what does this New Covenant offer mankind? The writer of Hebews went on to explain, by quoting from the prophecy of Jeremiah.

> *"This is the covenant that I will make with them after those days, saith the Lord, I will put my laws into their hearts, and in their minds will I write them, and their sins and iniquities I will remember no more."* (Hebrews 10:16-17)

This is the work of earth's Great Millennium. During its thousand years, the effects of sin and unrighteousness will be eradicated from the hearts of men, and in its place will be established the laws of righteousness. It will be a time of teaching, and a time of learning.

The prophet Micah wrote, *"The law* (new covenant) *shall go forth from Zion, and the word of the Lord from Jerusalem."* The righteous laws of Divine Government will go forth from the New Jerusalem.

A square drawn around the moon has a perimeter of 8,640 miles. It is the solar number – the diameter of the sun being 864,000 miles. Micah's statement *"the word of the Lord from Jerusalem"* has a Gematria value of 864. It is not by mere coincidence that the name Jerusalem, as it is written in the Greek text of the New Testament, also has a Gematria value of 864. It is the place from which Divine Government will go out to all the world.

In his vision, Ezekiel saw water flowing from under the temple at Jerusalem. It was healing water. Flowing down into the Dead Sea, it brought life to *"everything where the river flowed,"* (1008). In the vision, the Wadi Al Junan brought the healing water down from Jerusalem. The mouth of this wadi is 275 miles from the center of the Delta circle, the position of the Great Pyramid. It is the diameter of a circle whose circumference is 864 miles, representing the source of life – the sun, which in turn, represents God.

The perimeter of the square drawn around the Delta circle is also 864 miles. The relationship is magnificent, and reveals the precise planning of a Master Architect.

This book has presented overwhelming evidence for Divine Design in the topography of the Great Rift Valley, the flow of the river Jordan, the distances between important places and events recorded in the Holy Scriptures, and their relationship to the sizes of the earth, sun and moon, the distances between them, and to the Gematria of the names of both the Father and the Son, and the work of creation. It all ties together as a magnificent testimony to Intelligent Design.

In December 2005, a United States District Court judge pronounced as "unconstitutional" the teaching of intelligent design in Pennsylvania schools. I ask you, the reader, to consider: is the evidence presented in this book that of "intelligent design" or "unintelligent design?"

And, as for the abundance of evidence, I've merely

864 Miles – Perimeter of Square

864 Miles – Circumference of large circle

864,000 Miles – Diameter of Sun

864 = Jerusalem, Ιερουσαλημ

864 = The word of the Lord from Jerusalem, (Micah 4:2)

864 = Before me there was no God formed neither shall there be after me, (Isaiah 43:10)

864 = Cornerstone, γωνια (topstone of the Pyramid)

864 = God, Θεων

Mouth of Wadi al Junan

275 Miles

Great Pyramid

scratched the surface. The same Creator who placed these intricate relationships into planet earth, has indeed planned for eternity. This plan involves a pattern of time into which will fit His entire work of creation, salvation and reconciliation of man – His beloved human family.

In the brief outline of that pattern below, note that each seventh "day" is divided into seven more "days," each being followed by an eighth day. That great Eighth Day is the goal to which His entire plan is progressing. It is all accomplished through His dearly beloved Son – Jesus, whose number is 888.

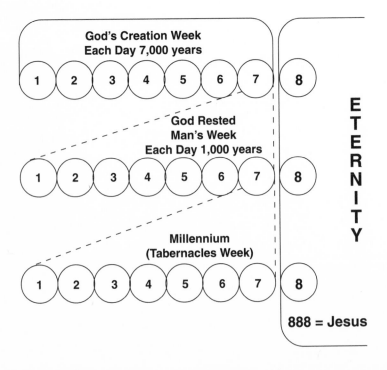

9

The Transfiguration

Banias fountain is said by the Rabbis to be the "source" of the Jordan. Its cold refreshing water originates as snow on the peak of Mt. Hermon.

Because of the beauty of this copious spring, and its abundant pure water, many made their homes there. In Roman times the village was named Caesarea Philippi. It is situated near the northern border of Israel, at the base of Mt. Hermon.

It was probably near this beautiful fountain that Jesus asked his disciples, *"Whom say ye that I am?"* Impetuous Peter was quick to answer. *"Thou art the Christ (Messiah) the Son of the living God."*

This was near the end of Jesus' ministry, and he knew he had to prepare his disciples for the fact that he would soon leave them. So he told them he would surely come again, not as a man, but as the glorified *"Lord of Lords"* (333). They could not

really comprehend this, so he said to them:

> *"There be some standing here, which shall not taste of death, till they see the Son of Man coming in his kingdom."*

They probably could not comprehend this either, but at least it gave them hope that their beloved Master would not be away very long. They knew this was a promise that they would see him again in their lifetime. But, the idea conjured up in their minds was not exactly what Jesus had in mind.

After six days from this conversation at Caesarea Philippi, Jesus took Peter, James and John up into Mt. Hermon. The scripture does not say when they left Caesarea Philippi, but it is likely the trek up the mountain took six days before they reached the desired location, for it was a very high mountain, and the marvelous events that happened there would be the fulfillment of what Jesus had promised, that some of those who were with him in Caesarea Philippi would not taste death until they had seen Jesus in the glory of his kingdom.

> *"And after six days Jesus taketh Peter, James, and John, his brother, and bringeth them up into a high mountain apart, and was transfigured before them: and his face did shine as the sun, and his raiment was white as the light. And, behold, there appeared unto them Moses and Elias talking with him."* (Matthew 17:1-4)

Peter, James and John saw Jesus, in vision, as the glori-

fied Lord of Lords (333) on Mt. Hermon whose position is defined by 33.3. What they were experiencing was a little glimpse of the Tabernacles Age, when Jesus will be the King of kings and Lord of lords. One wonders if Peter may have realized the connection, because his immediate response was, *"Let us make here three tabernacles; one for thee, one for Moses, and one for Elias."*

The Tabernacles Age – Millennial Day – follows the six "days" of man's history since the creation and fall of Adam. Thus it was fitting that the scripture tells us *"After six days"* they went up into the mountain where they saw Jesus in his Kingdom glory. *"After six days"* would mean it was on the seventh day they experienced this wonderful sight. Earth's Great Millennium is the seventh day on God's timeline for man.

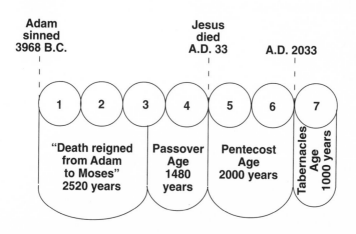

2520 + 1480 + 2000 + 1000 = 7000 years

Thirty five years after Peter saw this glorious vision of Jesus in his kingdom, he looked back at that wonderful day as one that was the most powerful witness to the truth of his faith. He said:

> *"We have not followed cunningly devised fables, when we made known unto you the power and coming of our Lord Jesus Christ, but were eyewitnesses of his majesty. For he received from God the Father honour and glory, when there came such a voice to him from the excellent glory, This is my beloved son, in whom I am well pleased. And this voice which came from heaven we heard, when we were with him in the holy mount."* (II Peter 1:16-18)

That *"holy mount"* was beautiful snow capped Mt. Hermon – the mountain which represents the dwelling place of God. How appropriate that the Gematria value of *"holy mount"* is 999, for this is the number of divine wholeness and completeness.

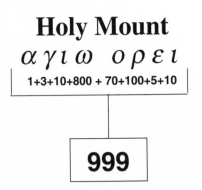

Holy Mount

$$\alpha \gamma \iota \omega \quad o \rho \varepsilon \iota$$

1+3+10+800 + 70+100+5+10

999

This story began with Mt. Hermon, the dwelling place of God, and has come full circle back to that *"holy mount."* And the story of salvation that has been given to us in the Bible began with the famous words *"In the beginning God."* That immortal phrase, which was read from space as man first orbited the moon, and looked back at the beauty of our earth – the place which God had given us for our home – takes on an amazing beauty when we realize it has a Gematria value of 999.

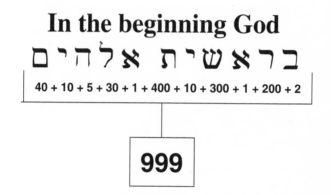

In the beginning God

בראשית אלהים

40 + 10 + 5 + 30 + 1 + 400 + 10 + 300 + 1 + 200 + 2

999

This magnificent display of the numbers is not a contrivance of man. None of us are that intelligent. And it certainly is not the invention of "unintelligent design." It is evidence of "intelligent design" – the work of the Master Architect, the Master Planner, the Master Mathematician.

His plan for man does indeed go in a circle, for all that was provided for Adam will again be restored to him and all of his posterity – God's human family.

Go in a Circle

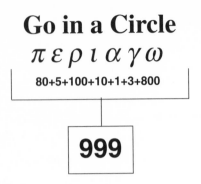

$$\pi \, \varepsilon \, \rho \, \iota \, \alpha \, \gamma \, \omega$$

80+5+100+10+1+3+800

999

In the beginning all was made in perfection; there was nothing that stood in opposition to the Creator. All, from the mightiest galaxies to the smallest microbe, obeyed only His will. But this sublime perfection of all things ceased when sin entered.

But the cycle marches on, and will revolve fully and completely back to perfection of all things. For this journey to be complete, it requires a payment be made for the original sin of Adam. When that payment is made, redemption and restoration can proceed.

Solomon stated this cyclic principle wisely and succinctly when he said, *"All the rivers run to the sea; yet the sea is not full; unto the place from whence the rivers come, thither they return again."* (Ecclesiastes 1:7)

The Apostle Paul gave the principle meaning and purpose in his letter to the Colossians:

> *"For by him were all things created, that are in heaven, and that are in earth, visible and invisible, whether they be thrones, or*

dominions, or principalities, or powers: all things were created by him and for him: and he is before all things, and by him all things consist.... And having made peace through the blood of his cross, by him to reconcile all things unto himself; by him I say, whether they be things in earth, or things in heaven." (Colossians 1:16-20)

Paul was making it very clear, the original perfection of the creation of all things will come full circle to the restoration to perfection of all things, and that this restoration is made possible by Jesus *"having made peace through the blood of his cross."*

This cycle of man's relationship to God is reflected in the cycles of the physical universe. The planets of our solar system rotate around the sun, going through their respective seasons and always returning to their original places.

This same cycling principle can be found in the atom, in which negatively charged electrons orbit the positively charged protons in its nucleus.

From the smallest to the largest of its components, the created universe goes in a circle. And likewise the relationship of man to his Creator goes in a circle – beginning in perfection and returning to perfection.

We have observed the relationship between snow-capped Mt. Hermon, the topstone of the Great Pyramid, and the sun, from which all life flows. The sun also goes in a great magnificent circle through the 12 positions of the

Zodiac, taking 25,920 years to return to its place of beginning. This immense circle of time, when divided by *pi,* will have a diameter of 8,251 years.

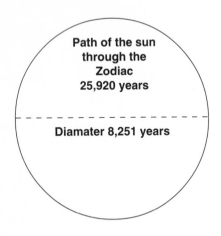

8251 = In Him was life, and the life was the light of men,
εν αυτω ζωη ην και η ζωη ην το φως των
ανθρωπων, **(John 1:4)**

Can we deny the magnificent relationship between the Father and the Son! This is why Jesus took Peter, James and John up the steep slope of Mt. Hermon and showed himself there in his heavenly glory.

The diameter of the path of the sun through the Zodiac, divided by the circumference of that path, will result in the number .318. How marvelous to realize that the Gematria of *"sun"* in the Greek text of the Scriptures, is 318.

$$8,251 \div 25,920 = .318$$

$$318 = \text{Sun, } \eta\lambda\iota o\varsigma$$

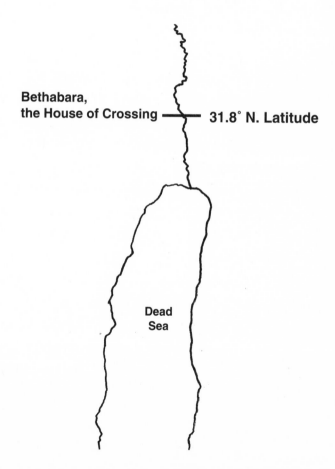

Bethabara,
the House of Crossing ——— 31.8° N. Latitude

Dead
Sea

It becomes apparent that the Great Mathematician has interwoven His great design into the most magnificent patterns of numerical lace. There is no way it could have happened by "**un**intelligent design." Our great God has left his fingerprints all over it!

Bethabara – *the house of crossing over* – is at 31.8 degrees north latutude!

No wonder it was the place where Jesus was baptized. No wonder it was the place where Joshua led the Israelites across the Jordan and into the Promised Land. No wonder it was the place where Elijah and Elisha crossed over Jordan; or where Gideon defeated the Midianites; or where Namaan washed seven times and was healed of his leprosy; or the place pointed to by the direct line of the ascending passage of the Great Pyramid!

This one place on the Jordan – *the house of crossing over* – is, in symbol, the place where atonement is made, where death is rolled back, where resurrection happens and where complete healing takes place.

Bethabara, whose Gematria value is 81, and whose location is 18 miles from the City of Adam, is the place of Beginning (1) and New Beginning (8), through the Lord Jesus Christ. It was there that Joshua took stones from the river and had them placed in a circle, indicative of the great circle of time that would bring all the children of Adam back into possession of all that Adam had lost. The circle that would take mankind from the life-giving waters of Mt.

Hermon, all the way back to those same life-giving waters.

And so it was, that Jesus took Peter, James and John on a six day journey up the slopes of that *"holy mount,"* and on the seventh day he appeared before them in his glorified radiance. Mt. Hermon, which is situated at 33.3° N. latitude, and 33.3° longitude (old method) represents the Throne of God whose Gematria value is 333.

333

333

+ 333

999

999 = Holy Mount, $\alpha \gamma \iota \omega \ o \rho \epsilon \iota$

When Peter taught the wonderful news of the Kingdom of God, he said *"We have not followed cunningly devised fables."* He knew the reality of the coming Kingdom, because he saw the glorified Jesus in the *"holy mount."*

The reality of that Kingdom is not *"cunningly devised fables."* We have the assurances of the prophets of old, and of the promises of God. Jesus, himself, promised his disciples that he would return.

Two thousand years have passed since Jesus was born

into this world. His birth was announced to gentle shepherds who were out in the fields beyond Bethlehem. They saw the sky light up with a brilliance and beauty far surpassing the aurora borealis. They saw angels! And not only did they see this magnificent display of heavenly glory, they heard them sing.

> *"The angel said unto them, Fear not, for behold, I bring you good tidings of great joy, which shall be unto all people. For unto you is born this day, in the city of David, a Saviour, which is Christ (Messiah) the Lord."* (Luke 2:10-11)

How's that for song lyrics? The shepherds were in awe. They were actually seeing angels, and they were actually hearing them sing. Then came the end of the song:

> *"Glory to God in the highest, and on earth peace, goodwill toward men."*

Those frightened shepherds probably stood there in stunned silence. Had the long-promised Messiah really been born in Bethlehem, they wondered? And what was that part about great joy, peace and goodwill? Are the words of our ancient prophets really coming true? They probably looked at one another in amazement; and when words finally came, they said, *"Come, let's go to Bethlehem."*

Two thousand years have passed since that memorable night. Yet the promised *"joy"* still seems elusive. Yes, a few have found joy in knowing and believing in the One who was born that night, but the promise was to the world – the

whole world, its nations and its billions. *"Let the nations be glad and sing for joy."*

We have just entered the third millennium since the shepherds heard that joyful message; and there is less joy among nations today than when the angels sang those hopeful words. Has the promise failed?

History has proven, God's promises never fail!

Throughout the prophecies of the Old Testament the promise of a Deliverer was given – a Messiah, who would be Anointed to perform a special work. He had come to be known as *"The Desire of Nations."* (Haggai 2:7) These prophecies told us that he would bring life to a dying people and peace to a troubled world. And Daniel was even given a time-table for the appearance of this Deliverer. The Apostle Paul, recognizing that God had a preset time for this Deliverer, said, *"When the fulness of time was come, God sent forth his Son."*

Precisely on that preset time the Deliverer did come. Recognizing this fact can give us confidence that precisely on God's preset time that Deliverer will indeed return to bring peace to the nations, just as He has promised.

The time appointed for the return of the Deliverer, when he will bring peace to the nations is earth's Great Millennium. Peace? Can we even imagine it?

First, think of all the massive and expensive weapons of war – weapons for killing our fellow man – confiscated and re-cycled into implements for peaceful use. Just

imagine all that could be built for the benefit of man with those raw materials, and with the money they represent. Does it sound a bit far-fetched? The prophet Isaiah didn't think so. He said:

> *"They shall beat their swords into plowshares, and their spears into pruninghooks. Nation shall not lift up sword against nation, neither shall they learn war anymore."* (Isaiah 2:4)

That promise means young men will not be required to learn the methods and tactics of war. There will be no military conscription, no military training camps, and no leaving families and loved ones to be shipped out to die on foreign soil. No, they will not even *learn* war anymore. This kind of world is worth dreaming about. But it's more than just a day-dream. It is reality.

Think of all the people who are in hospitals, nursing homes, asylums for the mentally impared. The joy has long gone from their lives. But the angels announced to the shepherds, *"great joy"* and to *"all people."* God has already made provision for the ill and the infirm. Just imagine – a world without sickness.

> *"God shall wipe away all tears from their eyes; and there shall be no more death, neither sorrow, nor crying, neither shall there be any more pain, for the former things are passed away."* (Revelation 21:4)

Too good to be true? Not if we believe God's word, for

He has promised it. He told Isaiah to write, concerning that Millennial Day of joy, *"The inhabitant shall not say, I am sick."* (Isaiah 33:24)

Isaiah had much to say about the joy that will come to all the people of the earth when Divine Government fills the world. He spoke of the healing of the blind, the lame, the deaf – not just a temporary repairing of the problem, but an everlasting healing. He said:

> *"Then the eyes of the blind shall be opened, and the ears of the deaf shall be unstopped. Then shall the lame man leap as an hart, and the tongue of the dumb sing."* (Isaiah 35:5-6)

Just imagine! No more nursing homes for the aged. No more rehab centers for the lame. No more pain pills for the hurting. No more hearing aids and no more implant eye surgery. It's a promise!

Perhaps our imagination does get stretched a bit, but remember, we are dealing with promises made by God. He has promised that even the vile person will learn righteousness. Can you imagine a world where everyone is courteous, and expresses loving actions in all their dealings with their fellow man? No more "in your face" responses. *"Out of the abundance of the heart, the mouth speaks,"* we are told, and God has promised that He will remove the stony heart from man and give him a heart of flesh. It is out of this *"abundance"* that man will deal with his fellow man.

God has promised that He will abundantly pour out His

spirit upon all mankind, causing wonderful changes in the hearts of men, resulting in righteousness and peace.

> *"Until the spirit be poured upon us from on high, and the wilderness be a fruitful field, and the fruitful field be counted for a forest. Then judgment shall dwell in the wilderness, and righteousness remain in the fruitful field. And the work of righteousness shall be peace; and the effect of righteousness quietness and assurance for ever. And my people shall dwell in a peaceable habitation, and in sure dwellings, and in quiet resting places."* (Isaiah 32:15-18)

Looking forward to this abundance from the heart of God is not just idle day-dreaming. It is laying hold on the promises of God, believing in them and looking forward with joy to the obtaining of them. So let's day-dream for a while. Close your eyes and picture a world filled with righteousness and peace and love. Blot out the world of today, with its misery and woe, degradation and sorrow – rise above the war and the killing and the horrors of man's inhumanity to man. Let your mind soar. Picture a perfect earth. The curse that was placed upon it has been lifted, and you can see the abundance of forests, fields and flowers. Its rivers flow in crystal beauty, reflecting the blue of the sky and the pureness of the air. And picture the earth populated with a perfect society of man. Imagine, if you can, a society that has not even a bitter thought, nor an unkind look or word, but love, welling up from every heart, meets a

kindred response in every other heart. Goodness and benevolence is the motivation for every act.

You see no sickness there, nor any who are lame. No suffering. No deformity or blemish of feature or character. Look upon all mankind and see their beauty of form and feature – each man and each woman a work of art. The eyes reflect the inward purity of mental and moral perfection. And each a reflection of the beauty of the God who made them and loved them.

No, it's not just a day-dream. It is the promise of God. And God always keeps His promises!

God's plan for man will have come full circle. And just as the refreshing, life-giving waters from Mt. Hermon bubble up in the three abundant fountains and flow down to fill Lake Huleh, so will it flow to all His dearly beloved human family. The beautiful garden that was prepared for Adam will become a world-wide garden, abundantly providing for the needs of all mankind. The curse placed upon the earth because of man's disobedience will be lifted, allowing the fulness of life-giving food for man, with all its nutrients in proper balance to sustain everlasting life. Yes, life will be everlasting. There will be no more funeral processions, no more saying goodbye to loved ones as they are lowered into the grave.

God promises that He will hear even before we speak. There will be no more wondering "If there is a God why doesn't He hear my prayer?" All will experience a personal

relationship with the God who loves them completely.

> *"I will put my law in their inward parts, and write it in their hearts, and will be their God and they shall be my people. And they shall teach no more every man his neighbor and every man his brother, saying, Know the Lord; for they shall all know me, from the least of them unto the greatest of them, saith the Lord: for I will forgive their iniquity and will remember their sin no more."* (Jeremiah 31:33-34)

> *"And the ransomed of the Lord shall return ... with songs of everlasting joy upon their heads."* (Isaiah 35:10)

The Dead Sea will have given up its dead; the walls of Jericho (man's governments) will have fallen down; the word of the Lord will have gone forth from the New Jerusalem to all the world. And man will be safely back into the sweet relationship with God which Adam enjoyed.

Joy to the world!

More on the Great Rift Valley and another great river: the Nile!

The Nile – the world's longest river – is a magnificent display of the amazing relationship of sacred geography and sacred geometry to the sacred gematria of the Bible, as well as revealing its awesome relationship to the dimensions of our earth, sun and moon. This mighty river, flowing through the deserts of Africa tells the story of the promises of God for the salvation of His human family. It includes the "living parable" of the work of explorer David Livingstone representing Jesus Christ, the antitypical "David" who is the "living stone." $14.95

More books by Bonnie Gaunt

The Bible's Number Code reveals an amazing link between Genesis and Revelation

Genesis One: This book reveals the exciting new discoveries of the Bible's hidden numbers that will transport you from our foundations in creation into the magnificent future that has been planned for man on planet earth. $14.95

Apocalypse: The Bible's sacred number code opens doors to the understanding of the book of Revelation, making the complicated simple, the feared an anticipation, and the outcome a magnificent joy. Using a few simple guidelines, the Apocalypse unfolds its amazing prophecies of today's world. It's here! It's today! And we are living in it. $14.95

The patterns of the Number Code and the patterns of time combine with the patterns of the Golden Proportion to tell God's magnificent story, and confirm our place, today, in His plan for man. A marvelous outline of the chronology of man. $14.95

A discovery of number patterns and prophetic time lines in the Bible. The Number Code takes us on a journey from Bethlehen to Golgotha and into the Kingdom of Jesus Christ. $14.95

The Bible's Number Code tells of the new Millennium and the "Grand Octave of Time" for man. Explores the amazing use of the Golden Proportion in the names of Jesus and in the time features of God's plan for man. $14.95

Order from Adventures Unlimited Press

The story of the scarlet thread is woven through the pages of time. This remarkable story has been revealed through the Word written, the Word in number, the Word in the cosmos, and the Word in stone. $14.95

Explores the "what" "when" and "how" of the origins of man, our earth, our solar system, and our universe. The Number Code reveals an amazing design interwoven into all creation – a design of which we are a part. $14.95

The constellations of the Zodiac tell the story of salvation and the second coming of Jesus Christ. The Number Code reveals the awesome message of the constellations. $14.95

Books by Bonnie Gaunt

NILE: the Promise Written in Sand
Stonehenge and the Great Pyramid
Genesis One
Apocalypse and the Magnificent Sevens
Time and the Bible's Number Code
Jesus Christ: the Number of His Name
The Stones and the Scarlet Thread
The Bible's Awesome Number Code
The Coming of Jesus
Beginnings: the Sacred Design

ORDER FROM

Adventures Unlimited Press
P.O. Box 74
Kempton, IL 60946 U.S.A.

Telephone: 815-253-6390
Email: auphq@frontiernet.net

$14.95

JORDAN
...the Promise Fulfilled

The Jordan, the most well-loved river in the Christian world reveals its secrets. Its pure sparkling water, descending from the snows of Mount Hermon, plunge into the Great Rift Valley and down into the lowest place on the face of the earth. It is the story of man's descent into death. But the river holds a promise – a God-given promise of life – revealed through its topography, geometry, and gematria. The amazing number code of the Bible is intricately interwoven into the sacred geography of the river and the sacred geometry of our planet, revealing a plan formed from the foundation of the world. The river becomes a magnificent confirmation of the Bible's story of salvation through the Lord Jesus Christ.

The author, Bonnie Gaunt, has been researching and writing about the Bible's number code (gematria) for more than forty years. She has appeared as a guest of Pat Robertson on the 700 Club, as well as on many television documentaries and radio interviews. Her work has received world-wide acclaim.

ISBN 1-931882-59-2

51495>

9 781931 882590

ISBN 1-931882-59-2

Adventures Unlimited Press